1. Hard Sleep

2. Soft Sleepers

3. Group Sleepers

I was born in Germany in 1968 and must have been just 18 years old when I first backpacked through the USA. Ever since, I have felt infected by the travel virus and whenever I have had the chance and time, I've just packed my bag, bought a flight ticket and taken off to somewhere new.

After my studies I started work for an international company. In 2002 I was sent to Beijing to work on the firm's joint venture in China, and a year later I moved to Shanghai to set up our new Chinese operation. Shanghai became my home for the next six years. Fascinated not only by the booming economy and pace of life but also by the many cultural differences, I enjoyed discovering the city and its people.

Around that time China became a kind of obsession for the Western media. News outlets around the world were warning us about the 'birth of a new superpower' and the 'rise of the Chinese dragon', often with a menacing subtext intended to frighten us. How fast China is developing, how competitive it is, and what a tense life the Chinese people must live! But I realized one day, after discovering people sleeping in public in

Sleeping Chinese

Bernd Hagemann

BLACKSMITH BOOKS

SLEEPING CHINESE

ISBN 978-988-17742-5-5
Published by Blacksmith Books
5th Floor, 24 Hollywood Road, Central, Hong Kong
Tel: (+852) 2877 7899
www.blacksmithbooks.com

the strangest positions and situations, that the reality was somewhat different, and far less threatening. Some of these apparently carefree people were even snoring in deep slumber on the street!

The accepting social attitude towards people sleeping soundly everywhere made me think that perhaps the China story focusing only on the frenetic economy was incomplete and unjust. I began to see another aspect of Chinese life and culture separate from the bustle.

I started to take photographs of these people so easily at rest. My collection of pictures grew and grew, and so did the interest in them. That was the birth of *Sleeping Chinese*.

With the launch of this picture book, I'd like to express my appreciation of the hard work and effort put in by all the migrant workers who play a central role in China's success story but seldom receive the attention they deserve.

Bernd Hagemann

我在1968年出生於德國，第一次當背包客橫越美國時，應該至少已有18歲了。自此以後，我就被那旅遊病毒感染，每當有機會及時間，總會收拾細軟，買張機票到一個新的地方去遊歷。

　　畢業後我在一家國際企業工作。在2002年我被調派到中國北京的聯營公司，一年後轉到上海，開設新的中國分公司。往後六年上海成為了我的家，我不僅對其迅速發展的經濟及生活的步伐感興趣，也著迷於這裡的不同文化，很享受發掘這城市及民眾的不同面貌。

　　差不多就在這個時候，中國這課題被西方傳媒纏繞著不放。各地的新聞通訊社都在警告我們有關這「新的超級大國誕生」及「中國巨龍甦醒」等，並且往往加上邪惡的註腳來嚇我們——中國發展得有多快，中國人生活在多麼緊張急速的環境中！然而在某一天，當我發現人們在公眾地方千奇百怪的睡姿時，

我忽然明白到媒體的報導和現實有點不太一樣，而且實際情況遠遠沒有新聞描述得那麼可怕。這些顯然是無憂無慮的人，部份更公然蟄伏在街上呼呼大睡！

　　社會上普遍接受這種在任何地方都可以大聲打鼾的現象，令我覺得只把重點放在中國瘋狂的經濟發展，或許並非完整、甚至是不公平的方式訴說中國的故事。我開始從另外一個角度，在喧鬧以外看中國人的生活和文化。

　　我拍攝著這些自在地睡覺的人，照片越來越多，別人對它們的興趣也越來越大，於是衍生了*沉睡的中國人*（Sleeping Chinese）網站的誕生。

　　藉著此圖書的面世，希望表達了我對這些民工艱苦工作及努力的欣賞；他們對中國今天的成功，起著非常重要的核心作用，然而卻總是沒有在國際社會上，獲得他們應得的重視和關注。

Bernd Hagemann

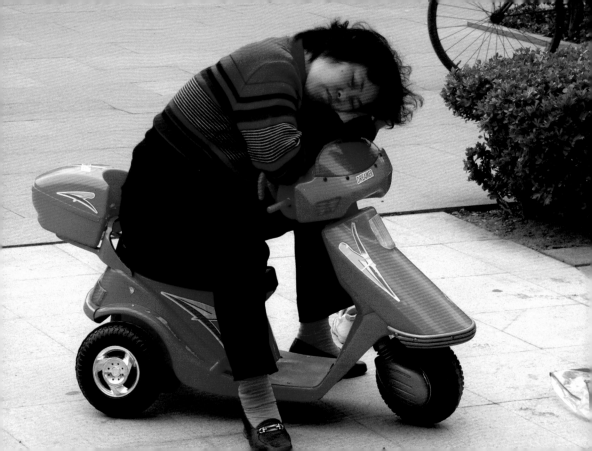

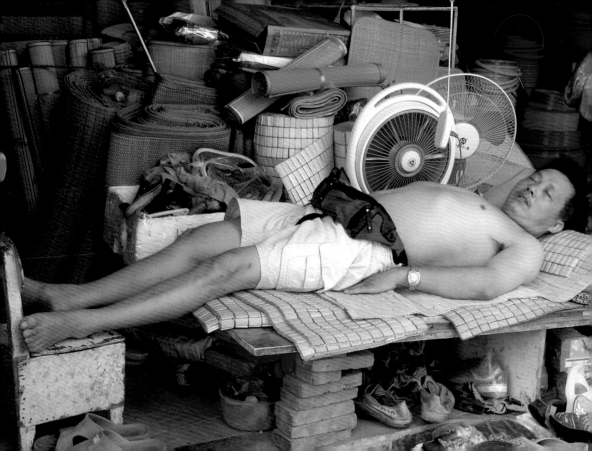

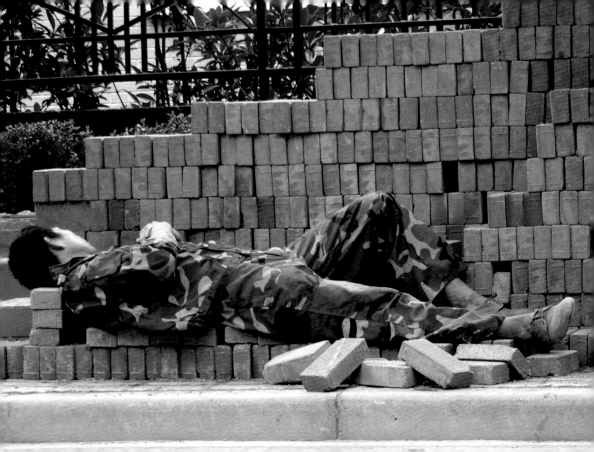

Hard Sleepers

Those who snooze in hard and uncomfortable places can fall asleep anywhere – even on piles of bricks in a construction site! In one of the most popular photos on the *Sleeping Chinese* website, a man in a uniform and peaked cap sleeps on a bench in a roadside park. He makes himself comfy on the armrest which is intended to prevent people from lying down. Although his body is contorted into an S shape, it doesn't stop him making Zs. This man is a hero of hard sleepers.

硬臥

那些無論在如何不舒適的地方都可以呼呼大睡的人，大概在那裡都可以睡著——即使要他們把建築工地上的磚頭堆當床舖，也不成問題。在*沉睡的中國人*網站其中一張最受歡迎的相片，就拍到一名身穿制服、頭頂大蓋帽的男子，在路旁的公園長凳上睡覺。他輕鬆地倚靠在那本來是用來防止人們躺臥的椅子扶手上，雖然他的身體S型躺著，也不妨礙他在打鼾。此男子是典型的硬臥英雄。

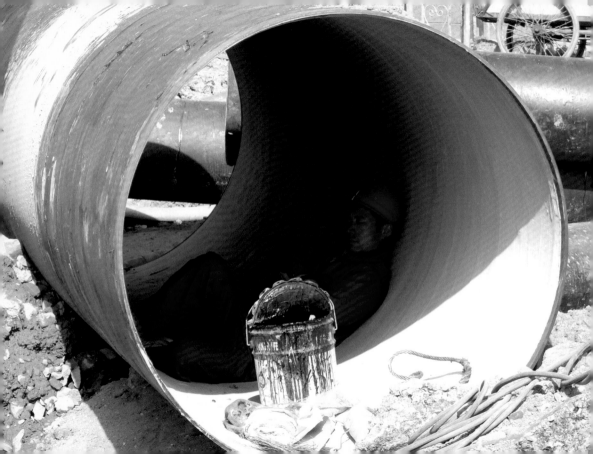

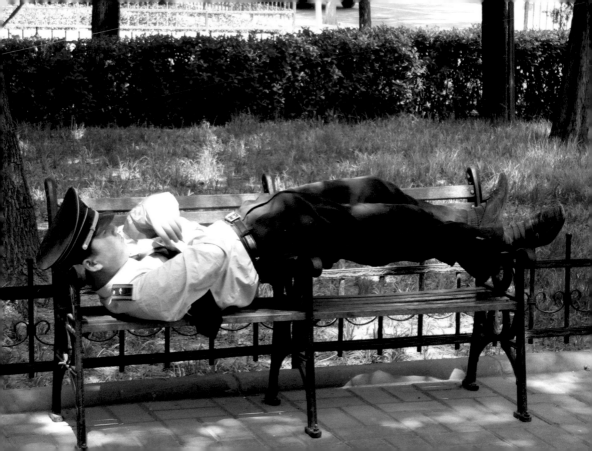

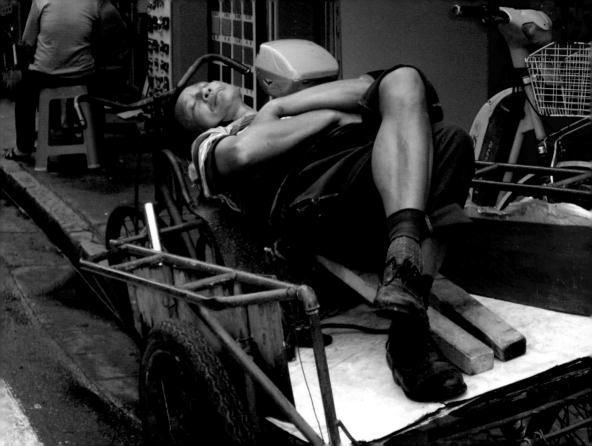

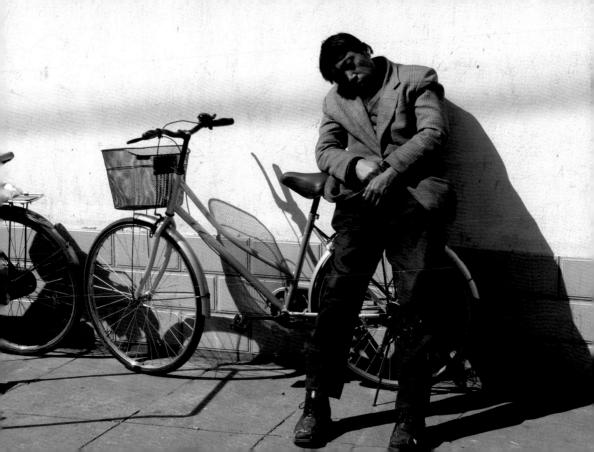

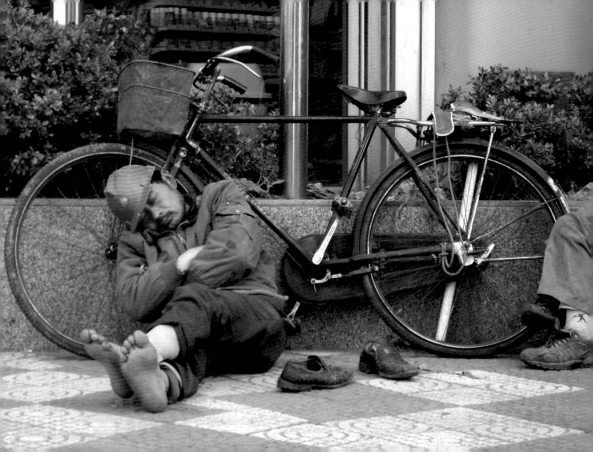

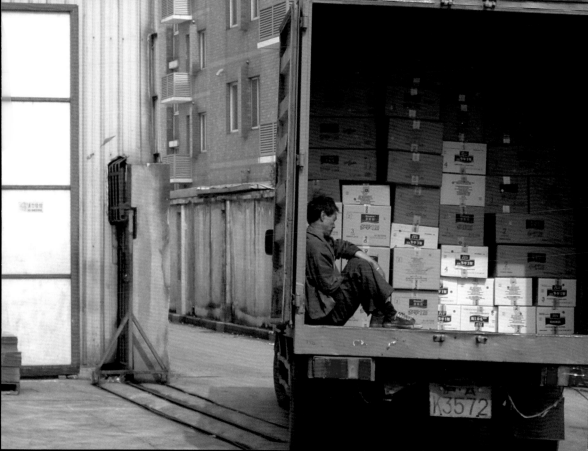

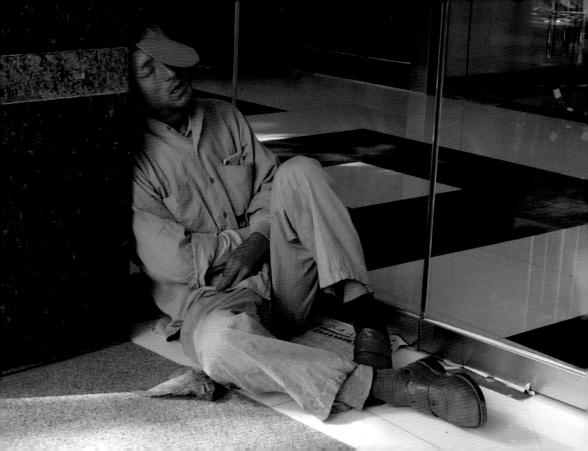

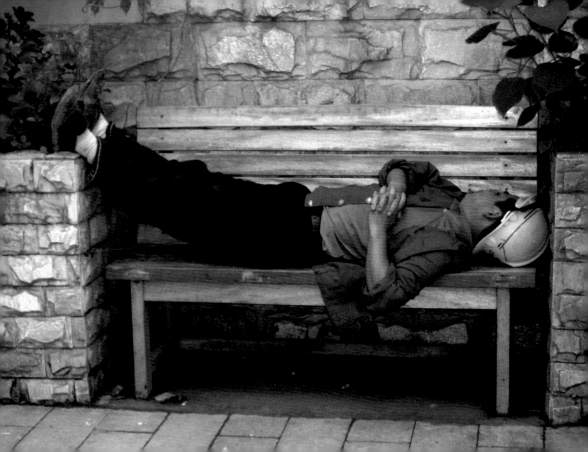

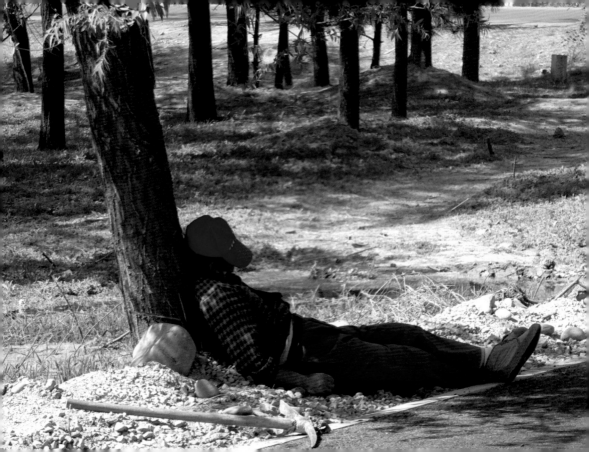

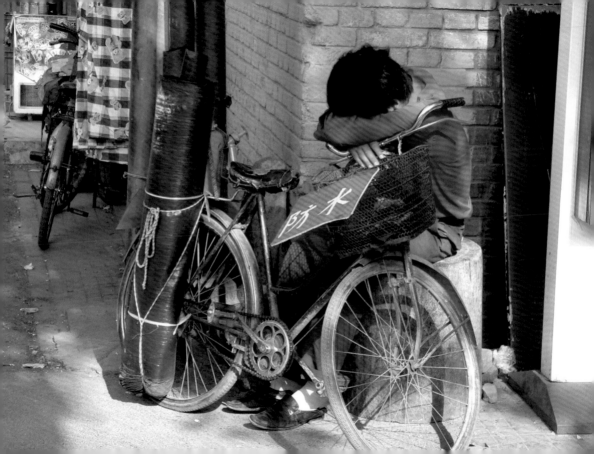

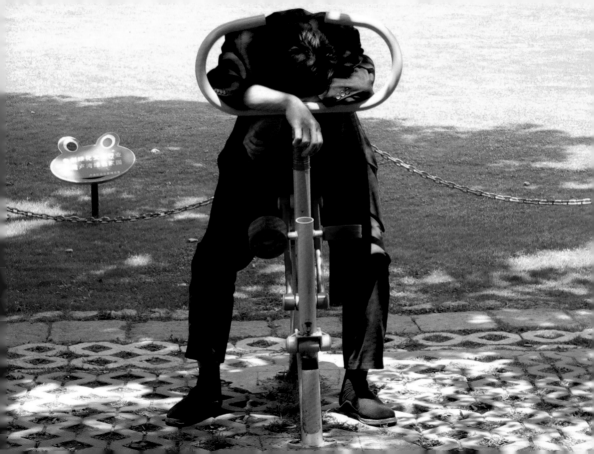

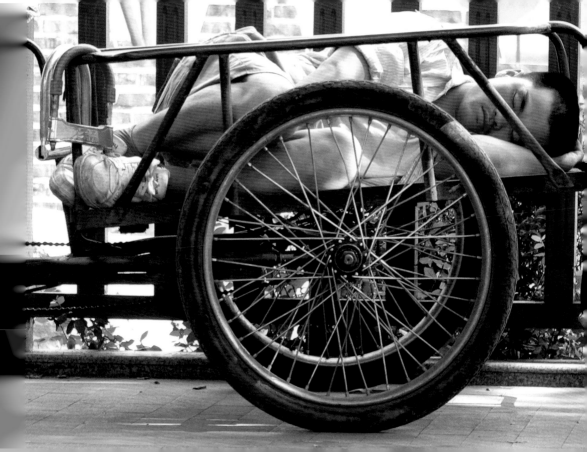

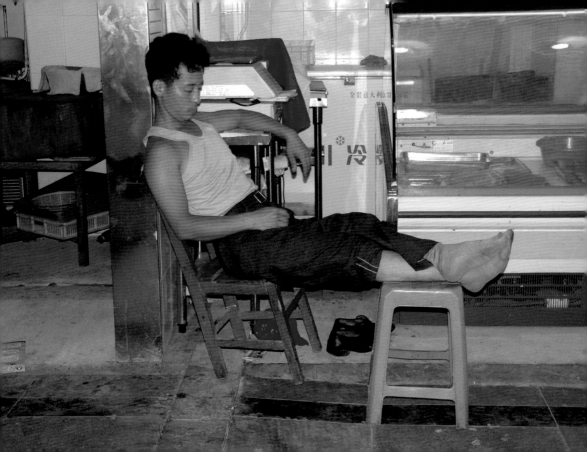

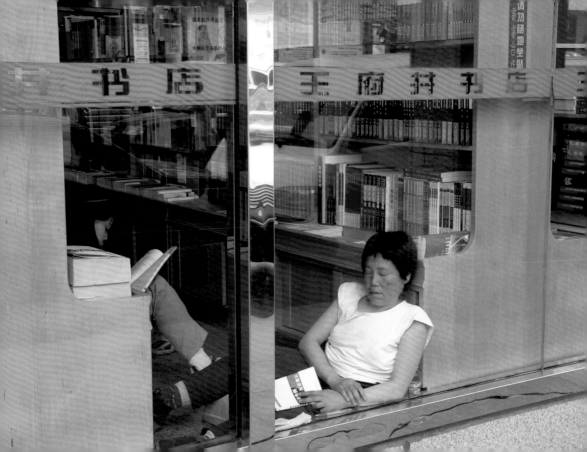

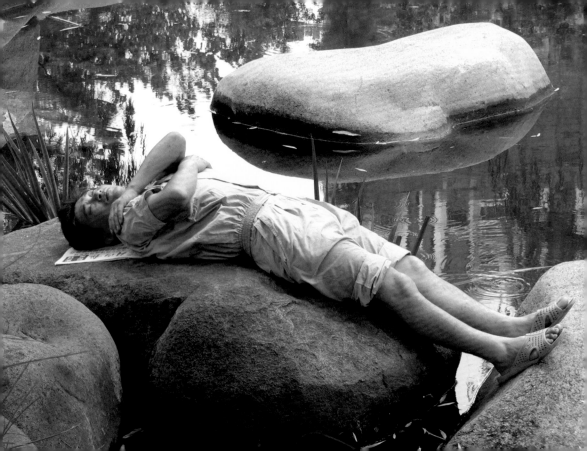

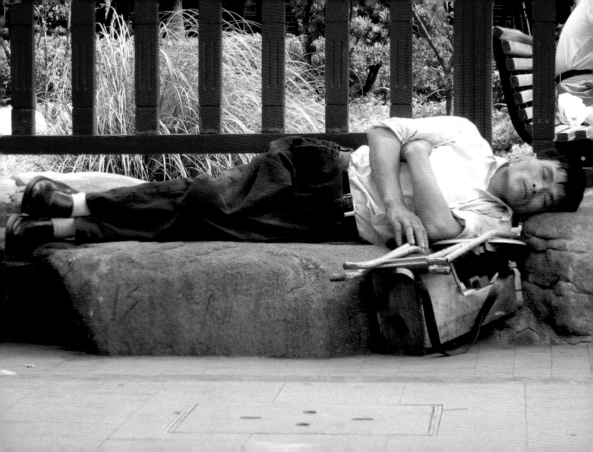

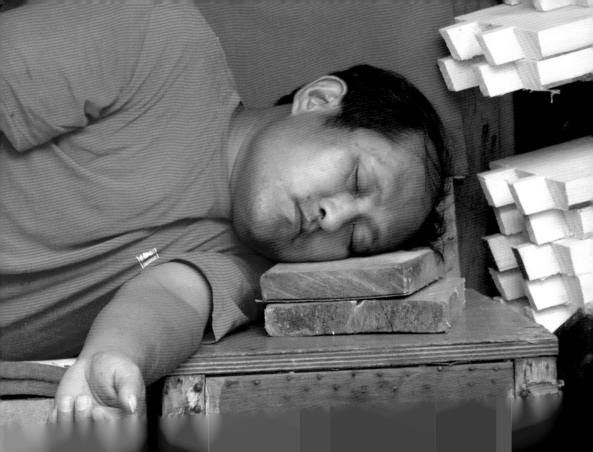

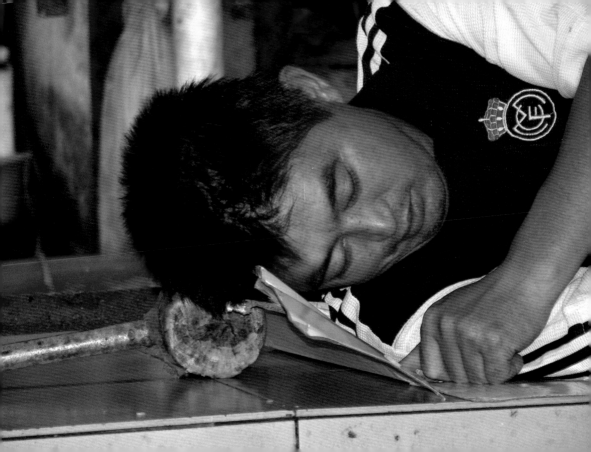

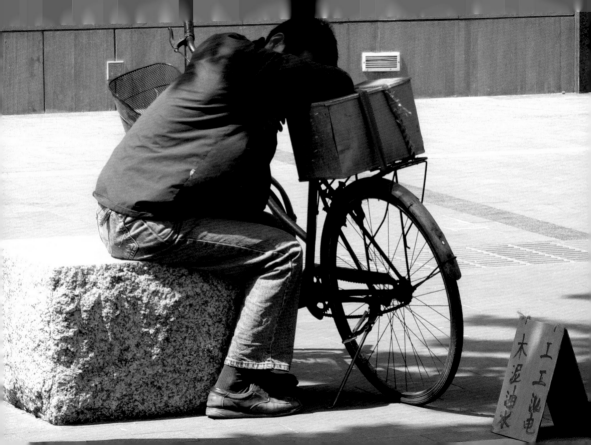

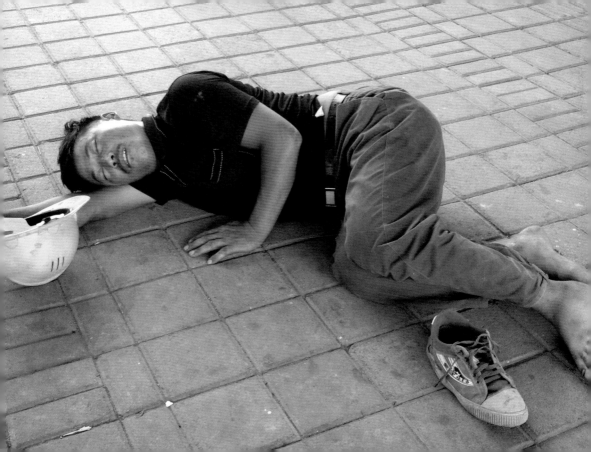

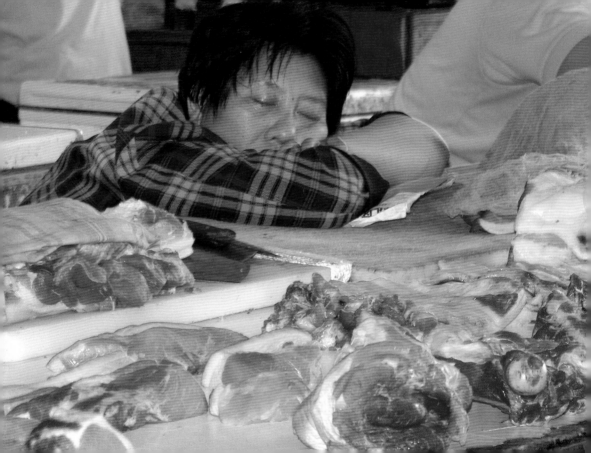

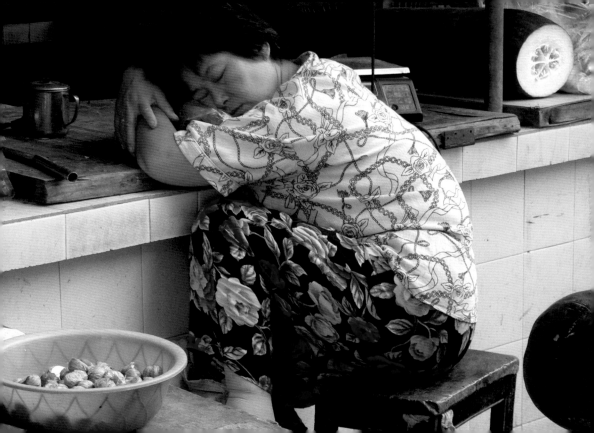

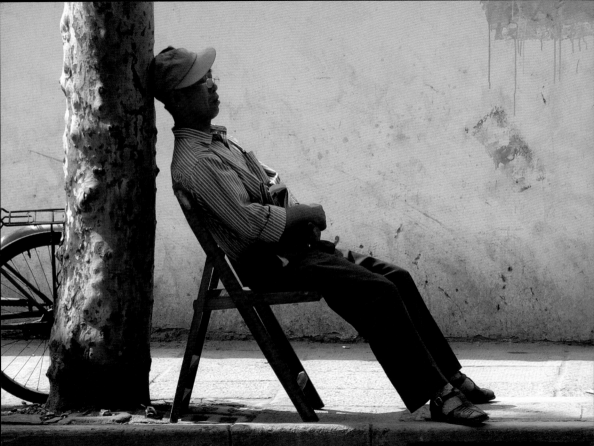

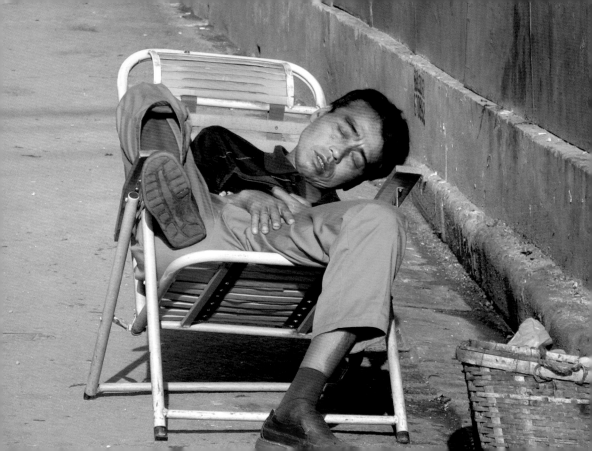

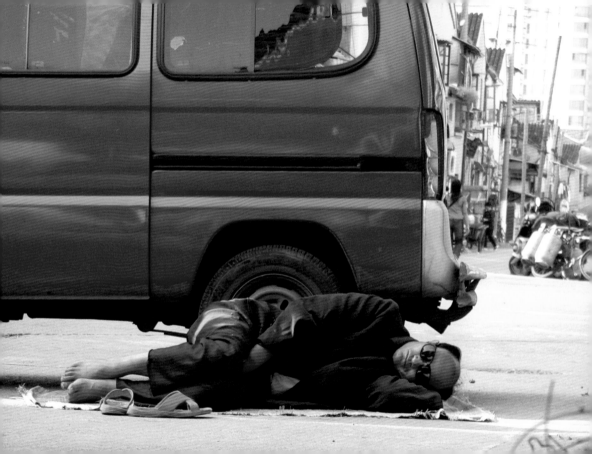

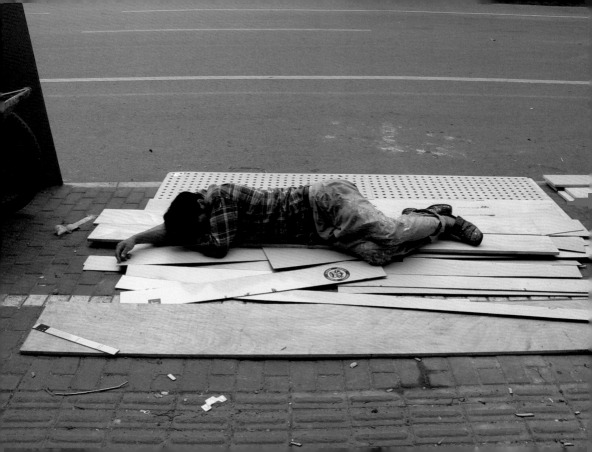

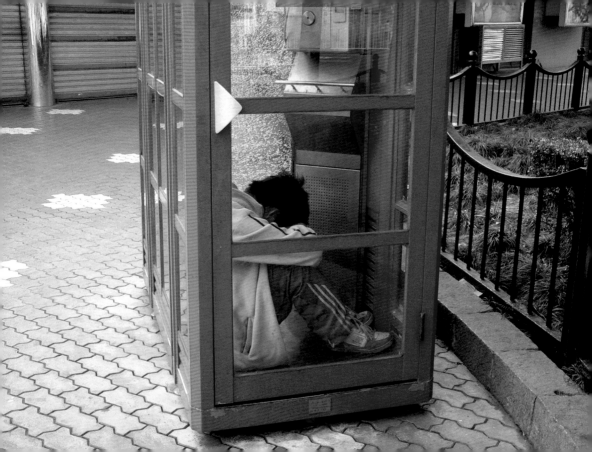

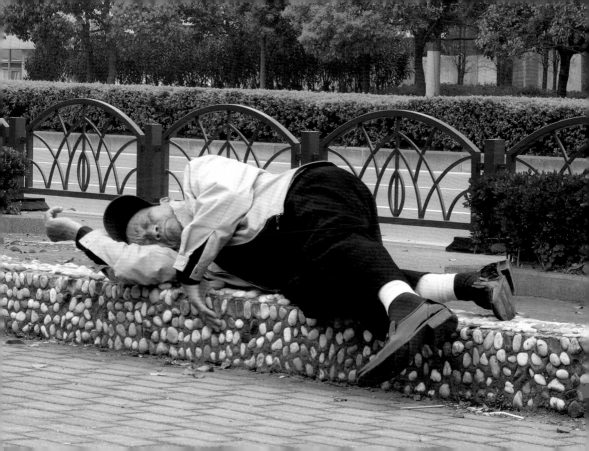

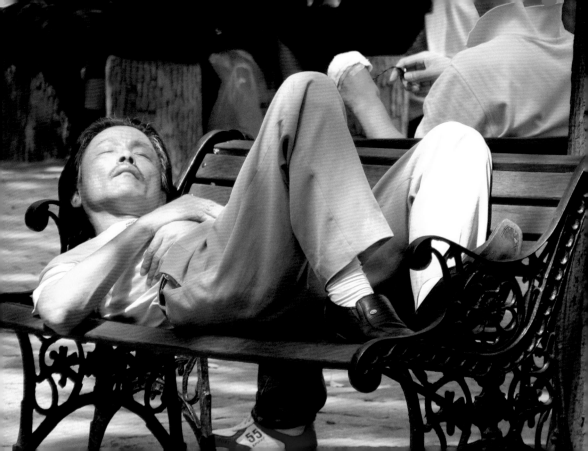

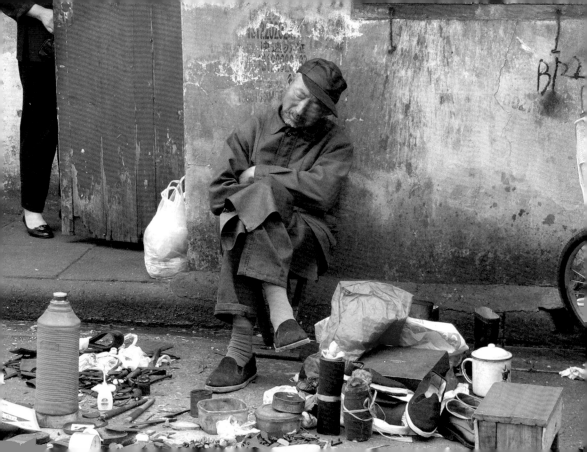

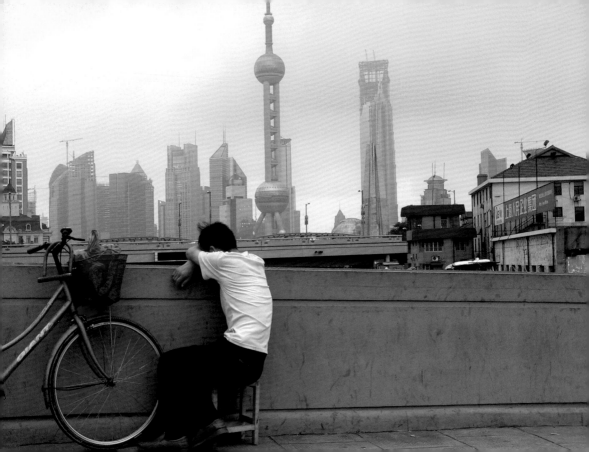

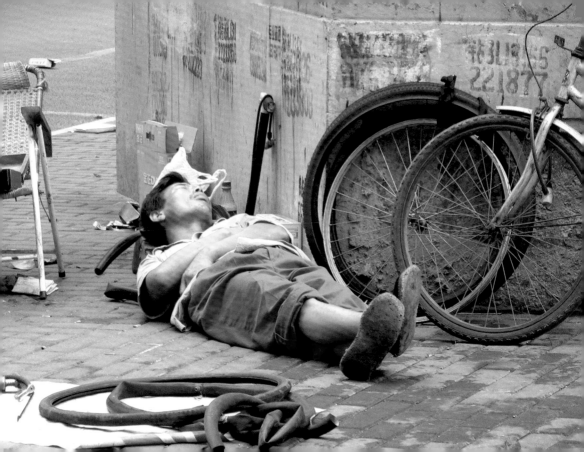

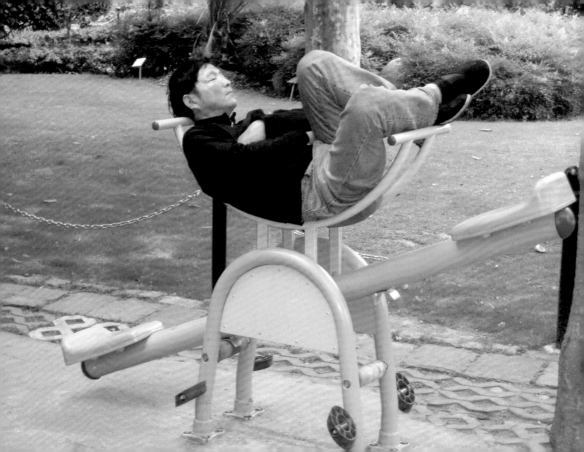

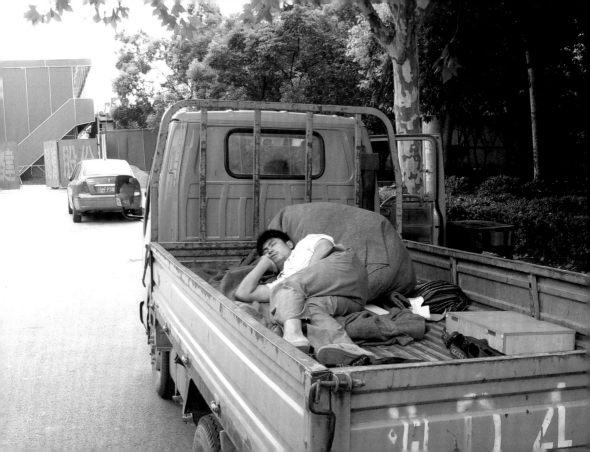

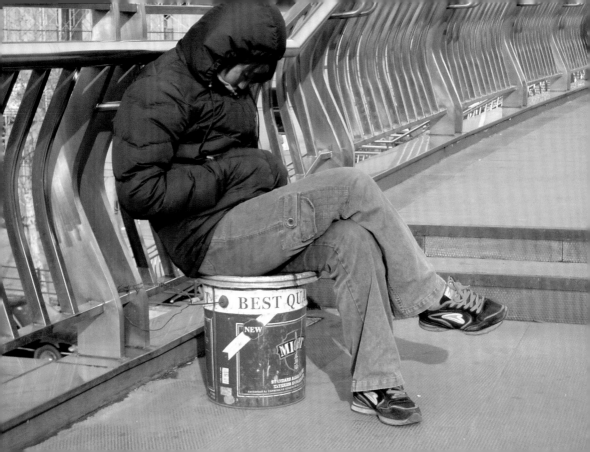

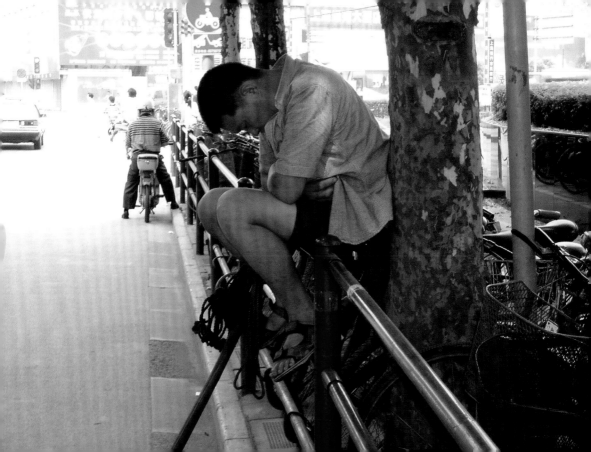

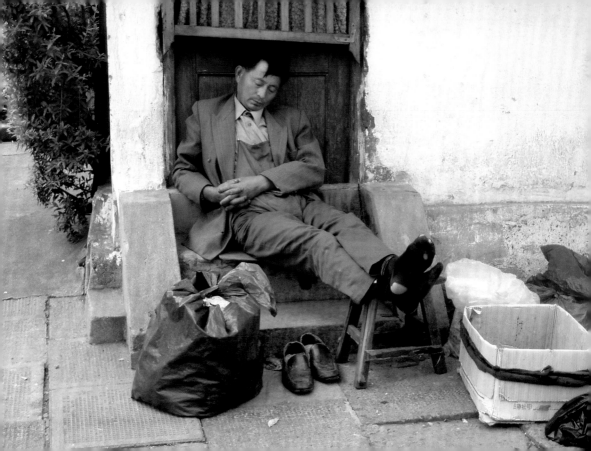

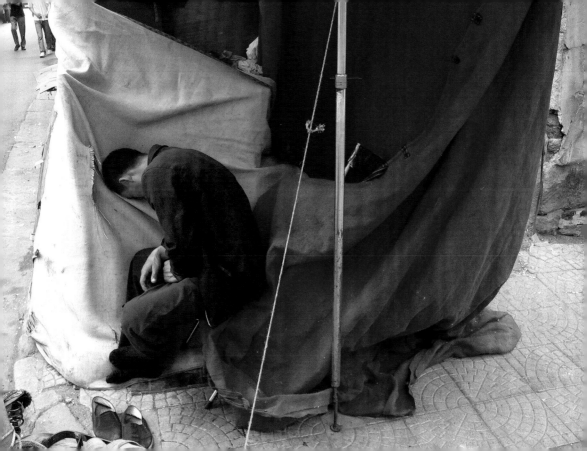

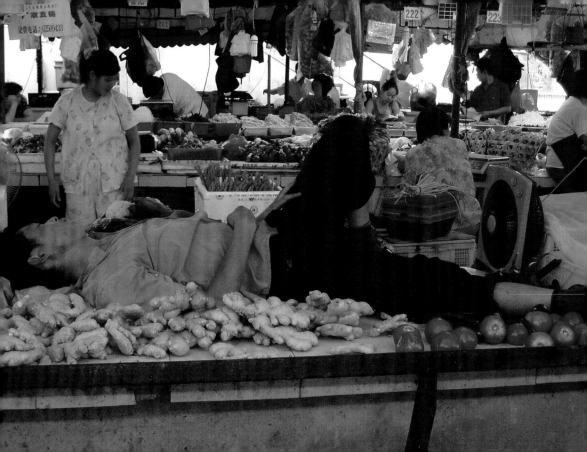

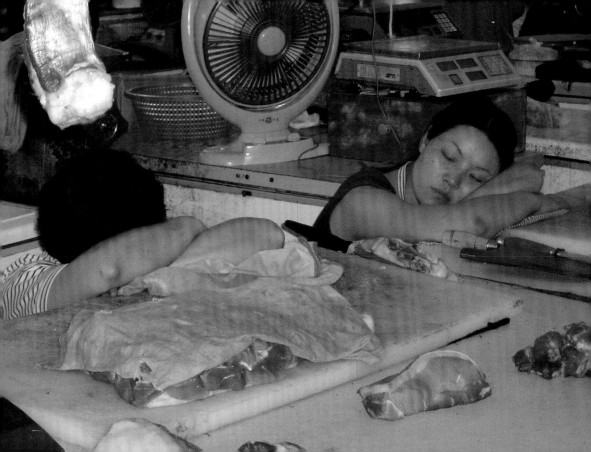

旺角站
Mong Kok Station

A1

香港鐵路附例在此適用。香港鐵路附例
的副本可於客務中心索取
Mass Transit Railway By-laws shall apply. Copies of the
Mass Transit Railway By-laws are available from the
Customer Service Centre

本站設有閉路電視
CCTV cameras are in operation in this station
香港鐵路附例 請勿吸煙 違者罰款5,000元
No smoking on MTR premises. Maximum penalty $5,000

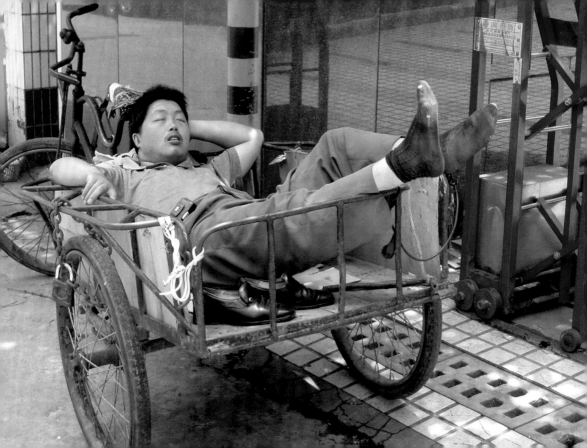

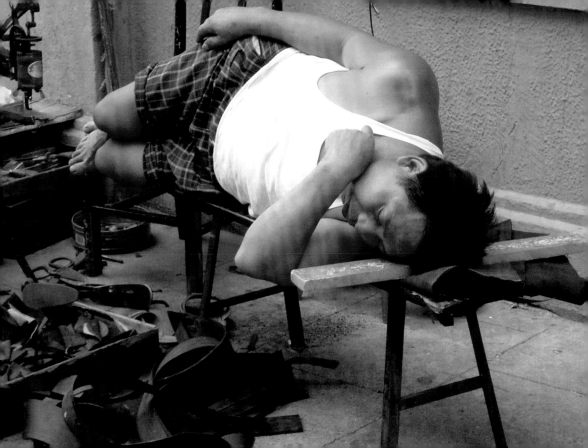

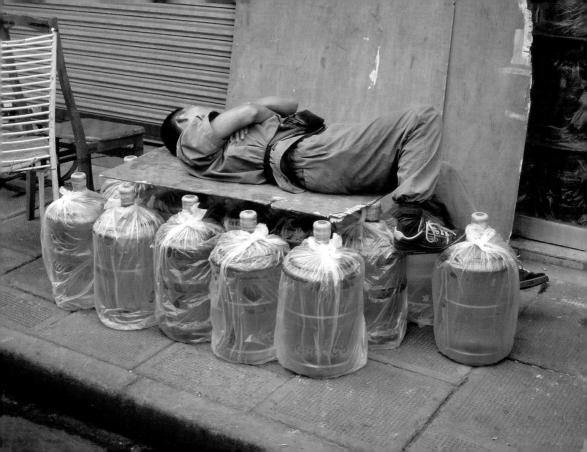

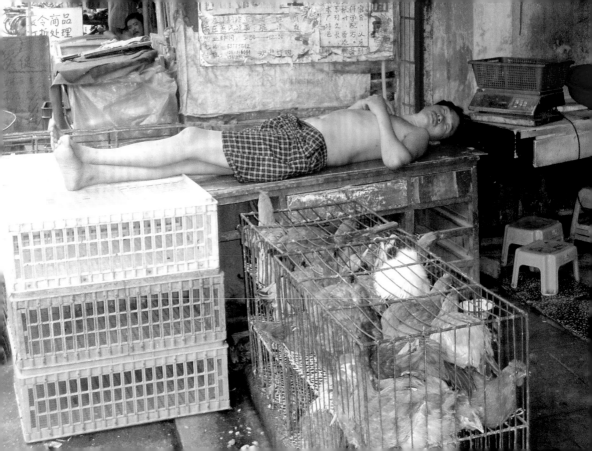

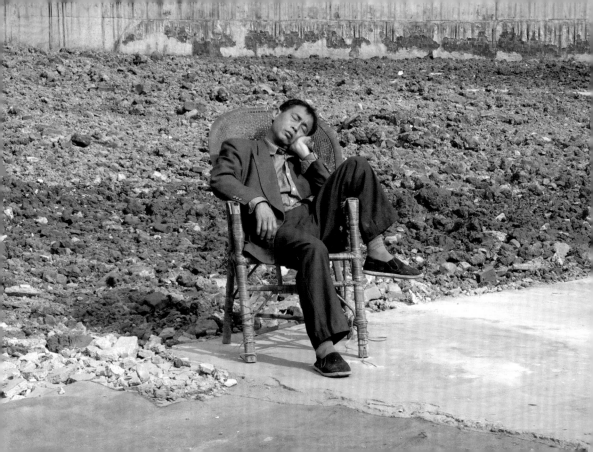

Soft Sleepers

Although those who prefer soft and comfortable places can also happily snooze in public, they are a little more fussy than their hard sleeper comrades. One truck driver with a hammock swung under his cab is a typical example. In another picture, a salesman in a fish market snores in a red plastic tub. Although large crabs are rattling around nearby, the sound of running water soothes him to sleep and he enjoys happy dreams in his plastic cradle. Those who shade their eyes from sunlight are also classed as soft sleepers.

軟臥

雖然喜歡睡在高床軟枕等舒適地方的人，依然可以於在公眾地方高興地酣睡，他們總是比硬臥類的朋友來得講究麻煩。當中的典型例子有貨車司機在他的駕駛室內放著吊床，或是售貨員在魚市場內酩酊大睡在紅色膠盆內。雖然在魚市場內有大蟹在嘎嘎聲叫，那流水聲卻能助他入眠，還在他的膠搖籃內做甜夢。那些在陽光下要遮擋著眼睛的人，也屬於軟臥類。

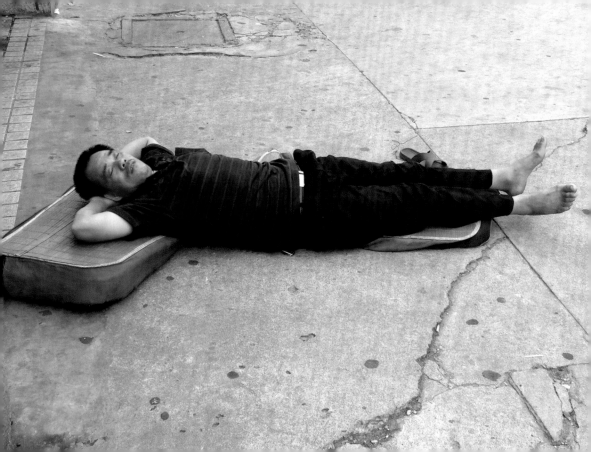

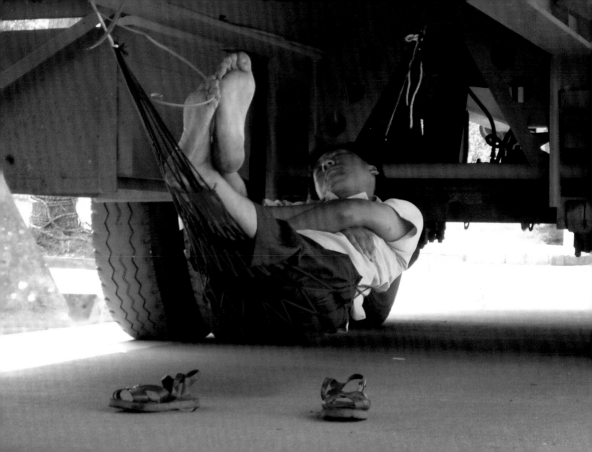

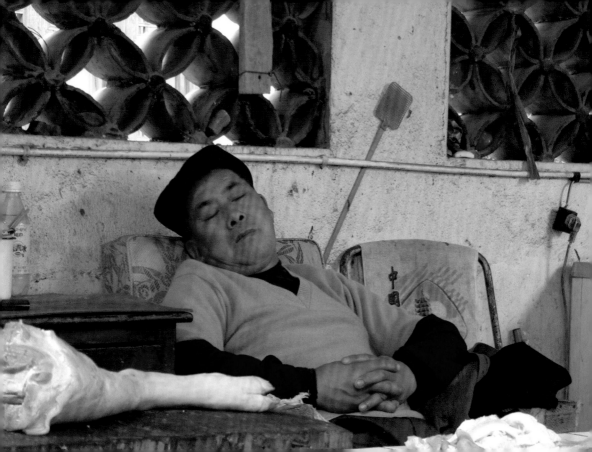

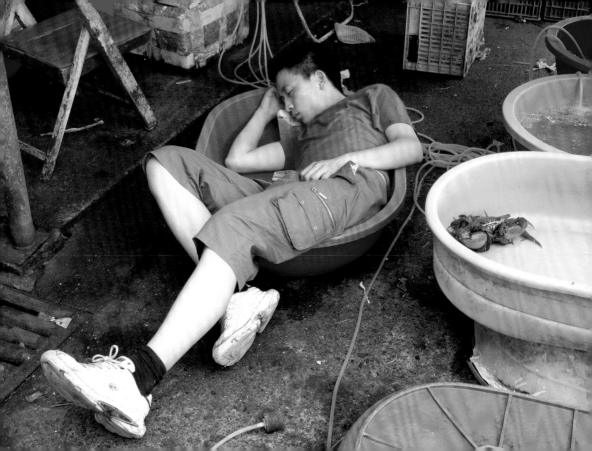

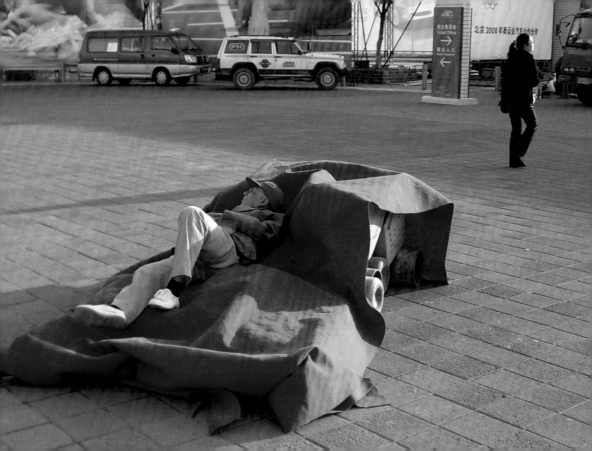

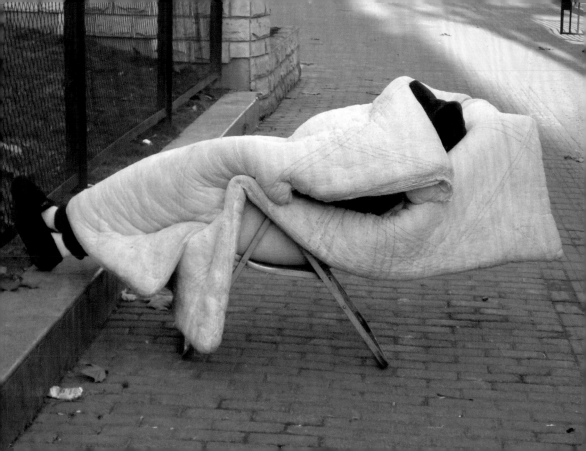

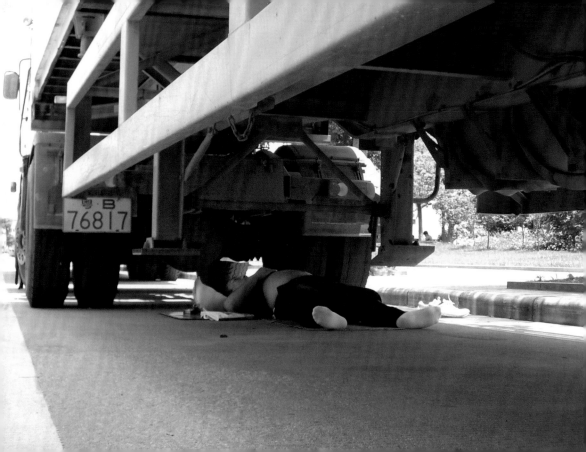

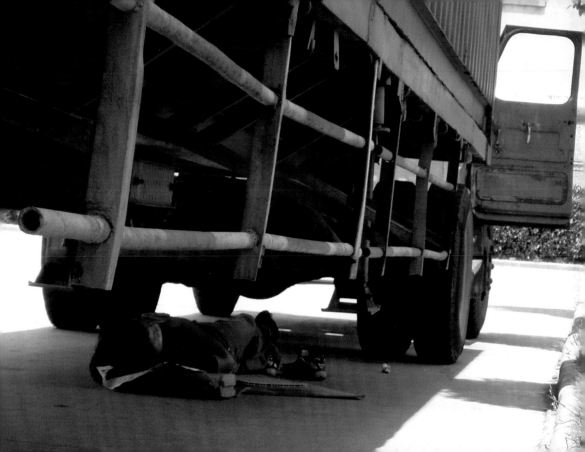

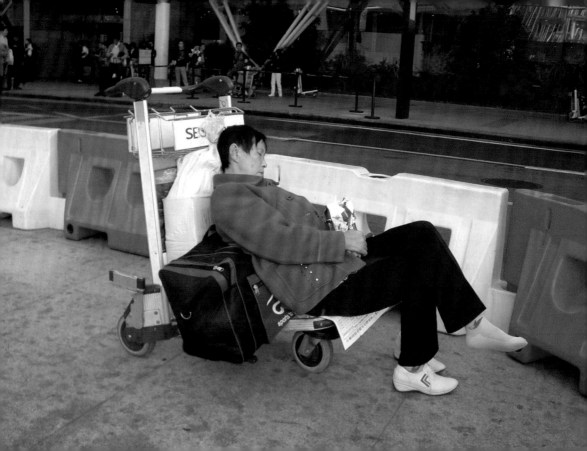

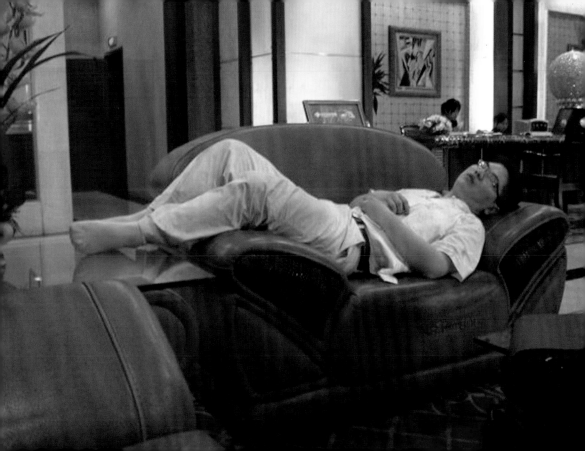

上海鑫港废品回收有限公司
废品收购价目表

黄板纸	元/公斤
书刊	元/公斤
报纸	元/公斤
杂塑料	元/公斤
棉花胎	元/公斤
不锈钢	元/公斤
废铁	元/公斤
黄铜	元/公斤
紫铜	元/公斤
铝合金	元/公斤
杂铝	元/只
可乐瓶	元/只
杂瓶	元/只
易拉罐	元/只
废家电	元/只

以上以市场行情修订价目
63037942

手机专卖

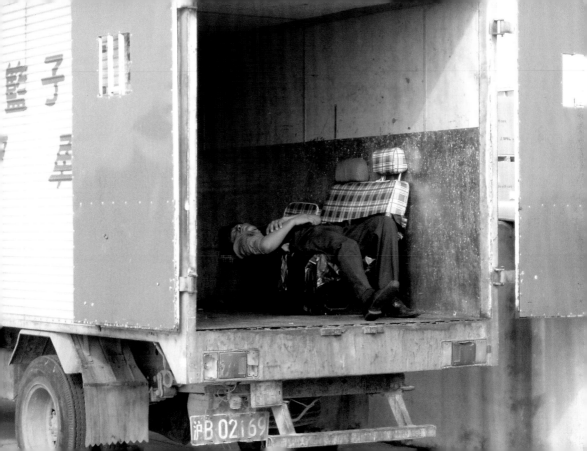

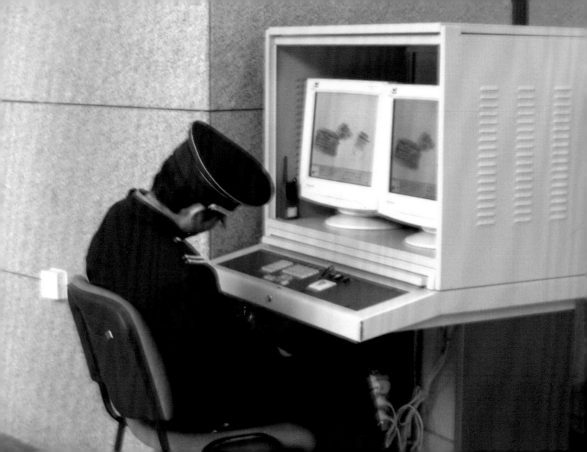

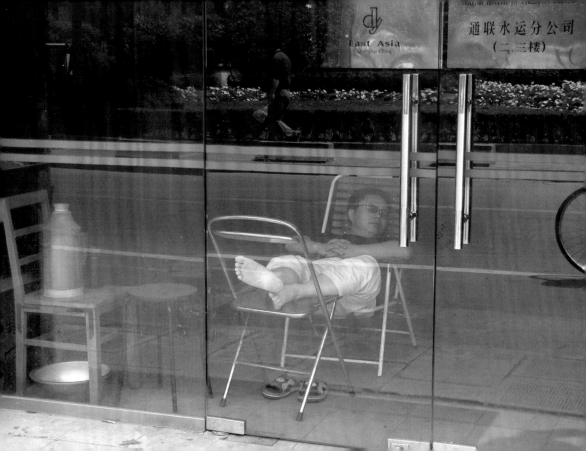

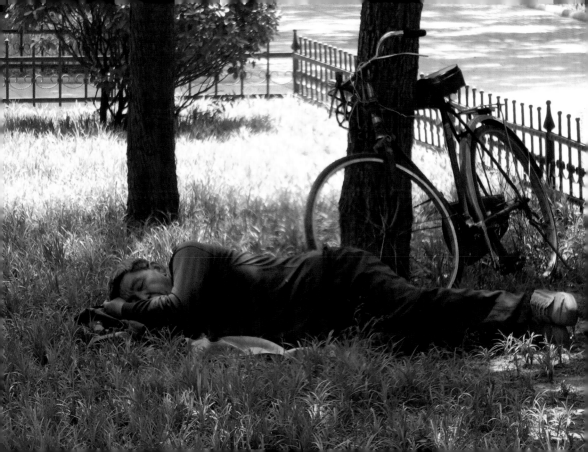

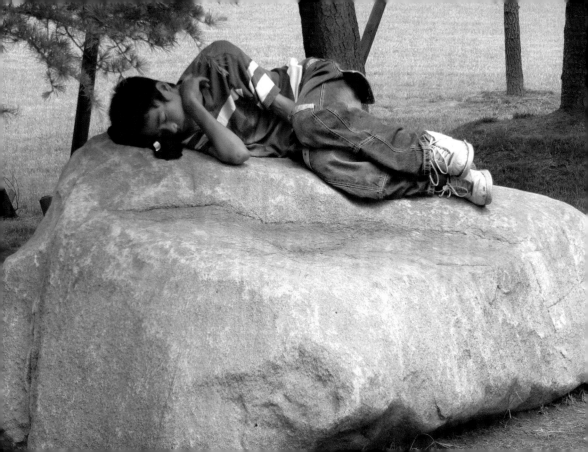

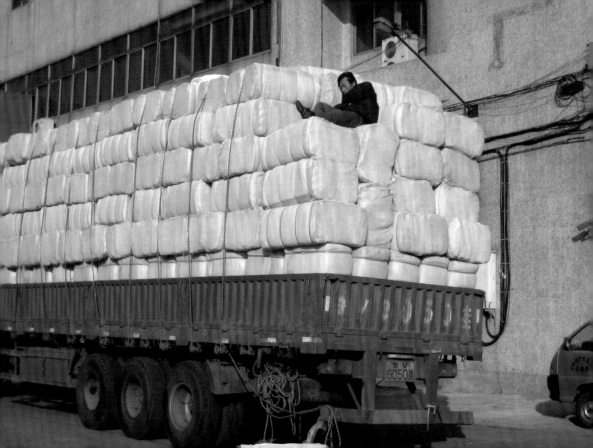

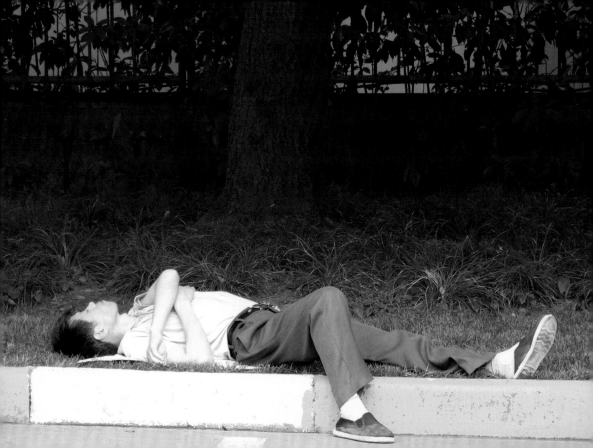

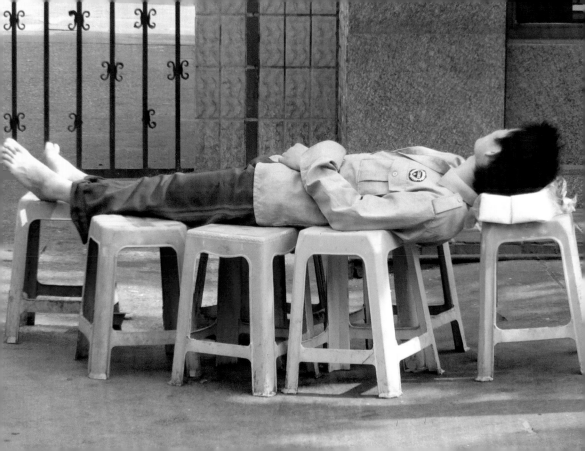

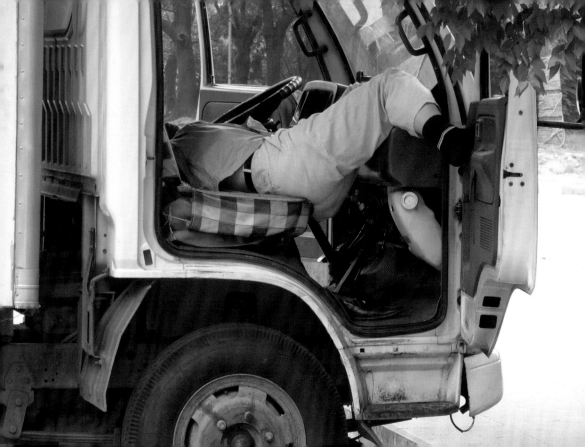

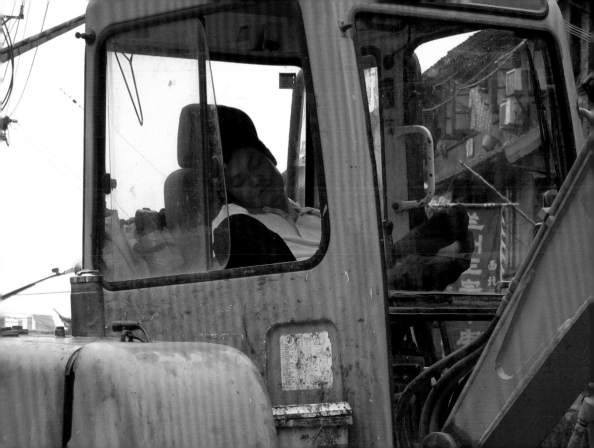

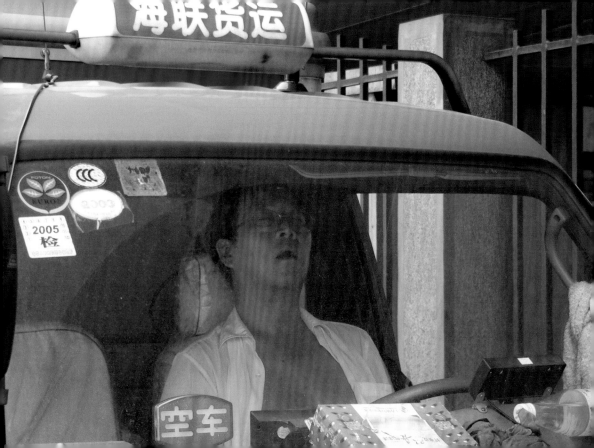

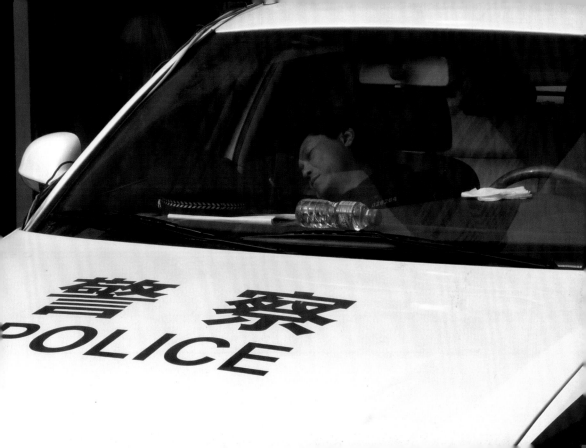

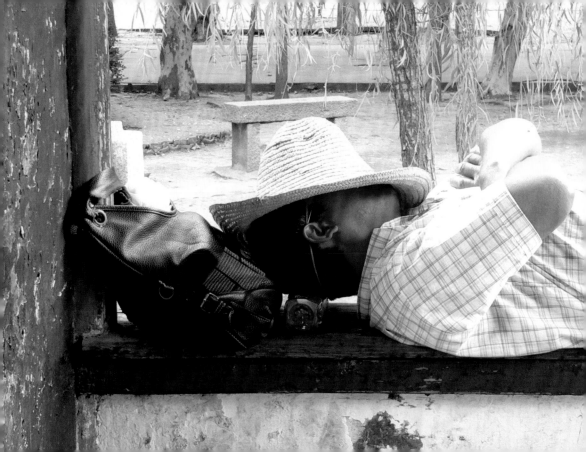

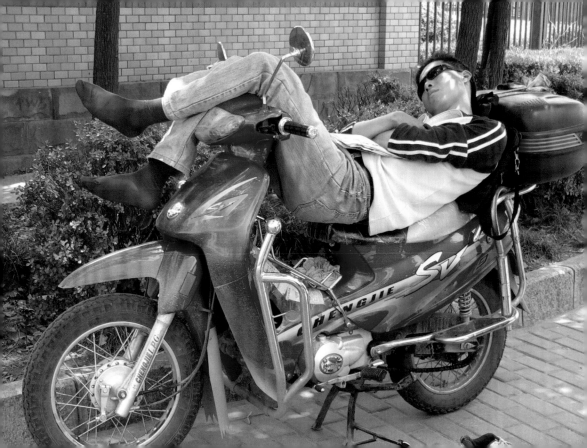

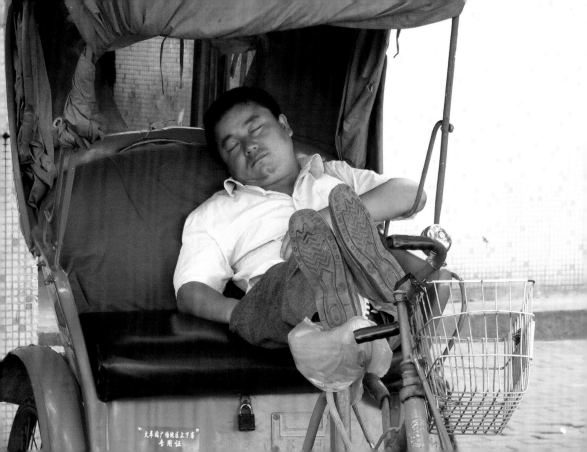

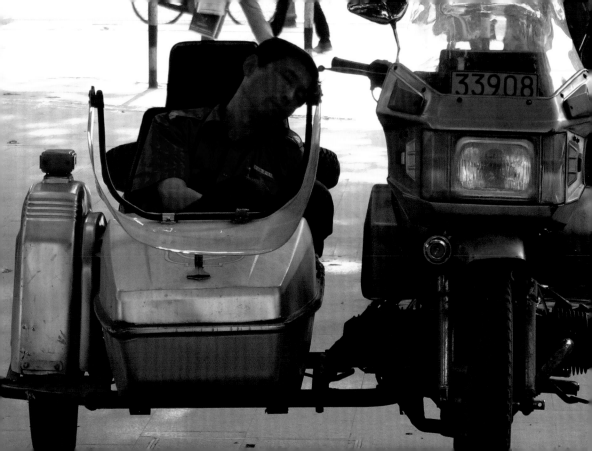

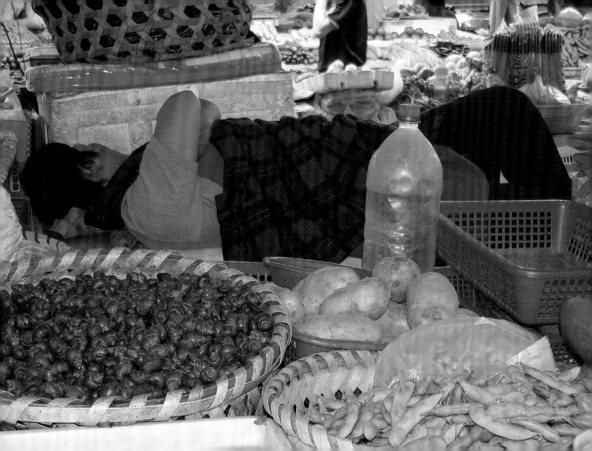

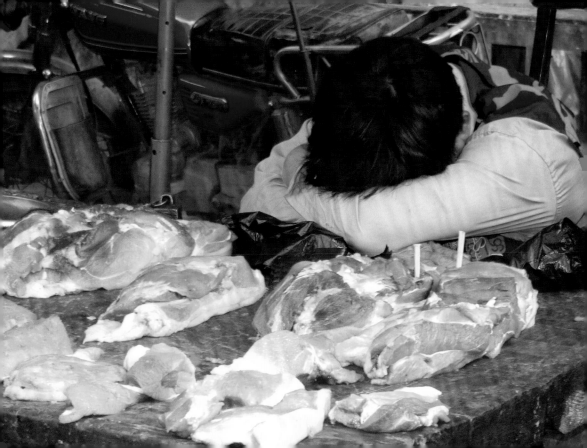

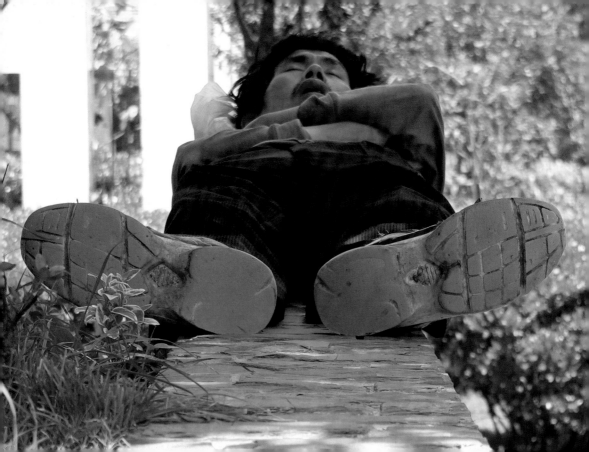

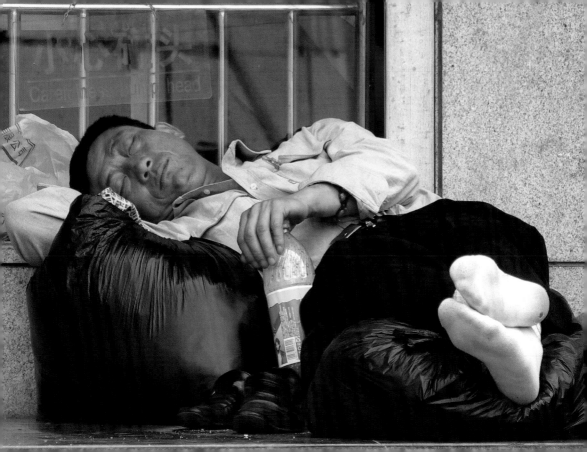

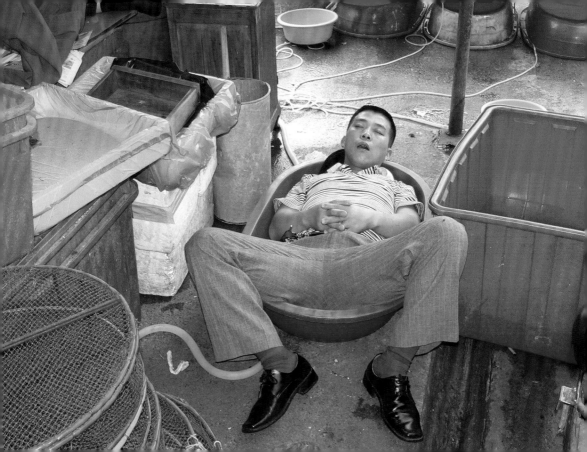

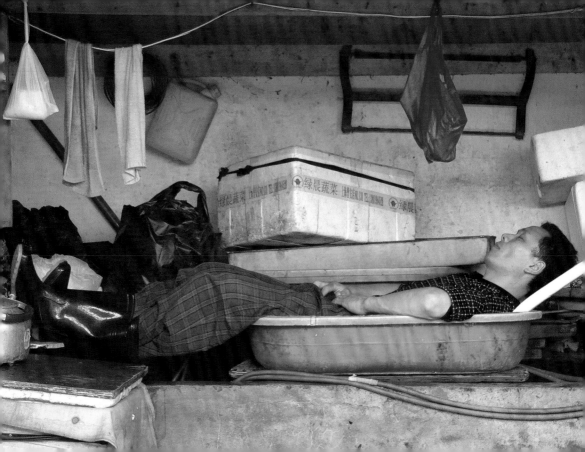

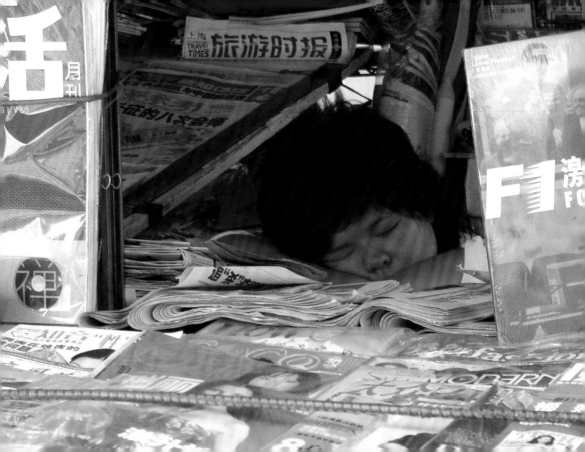

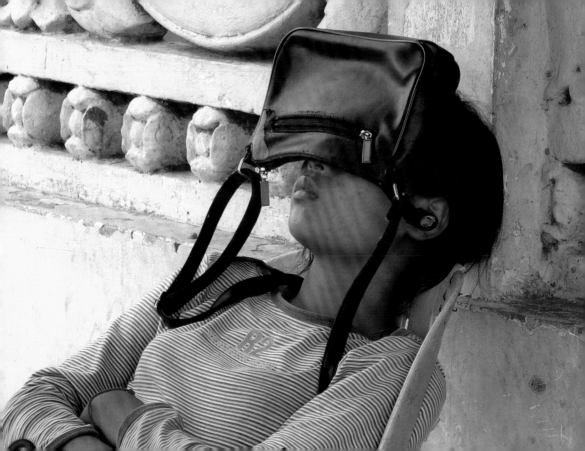

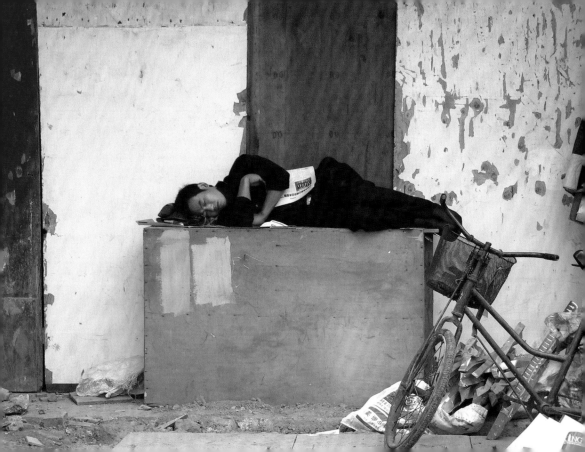

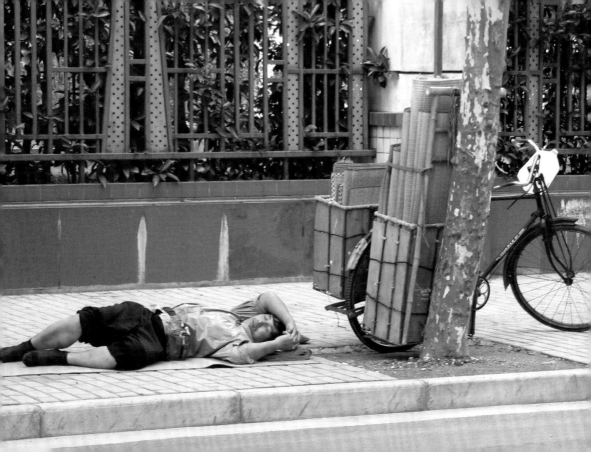

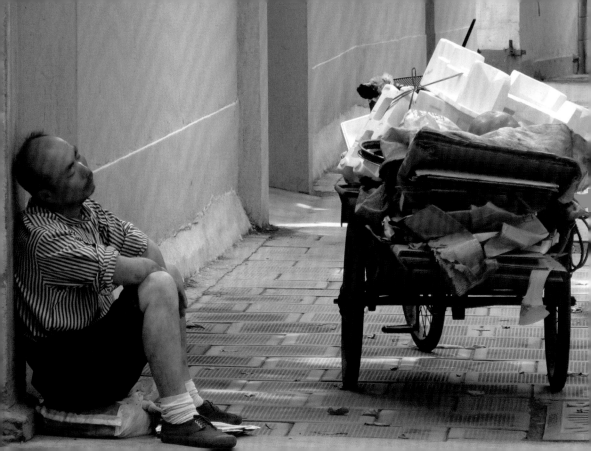

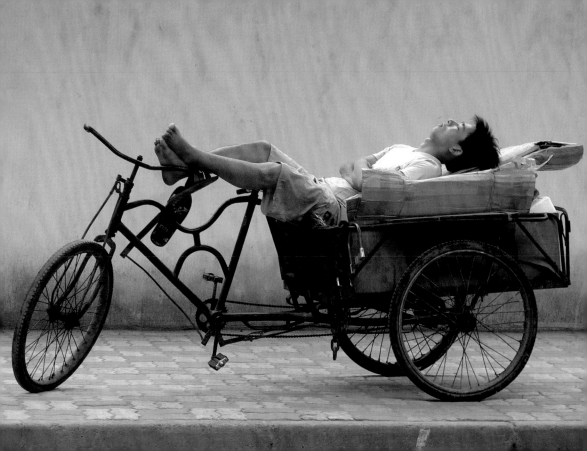

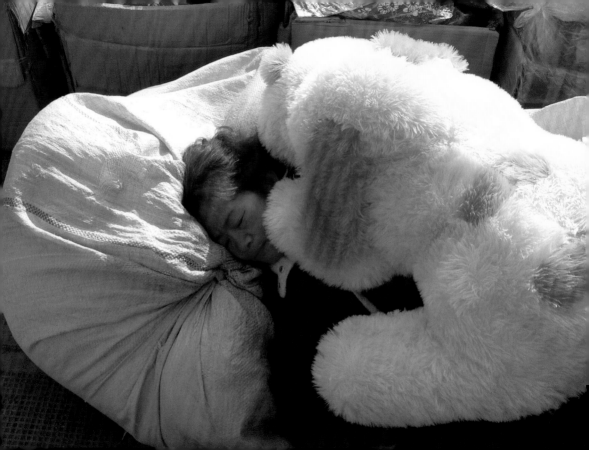

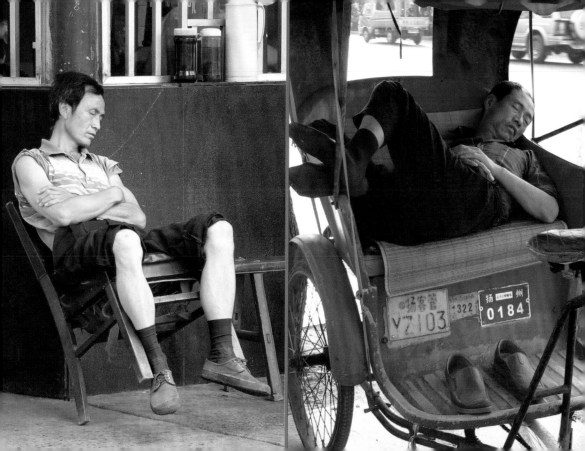

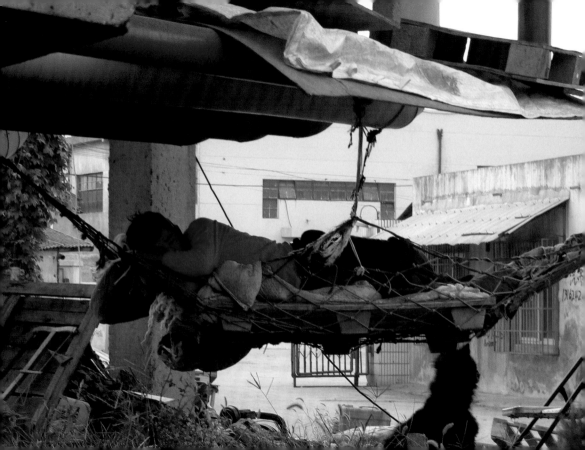

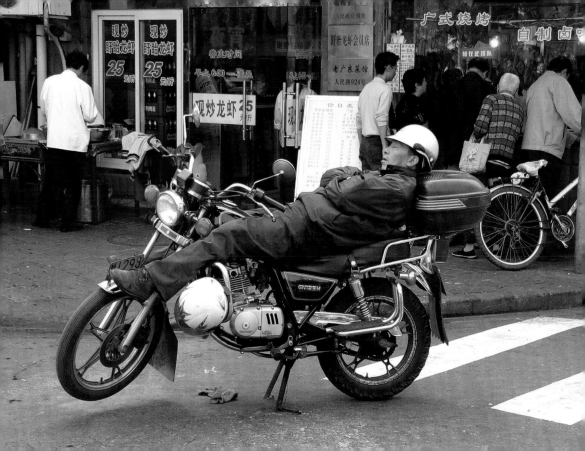

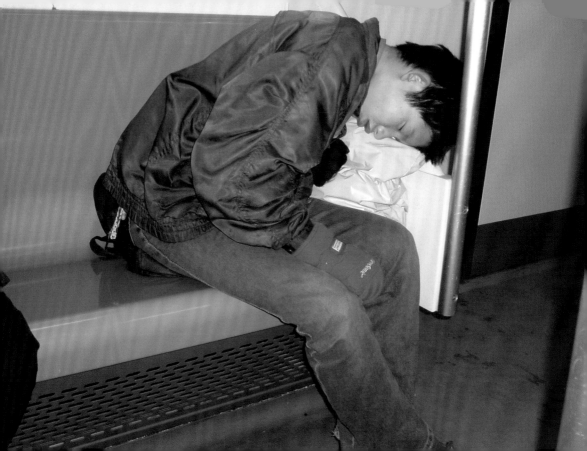

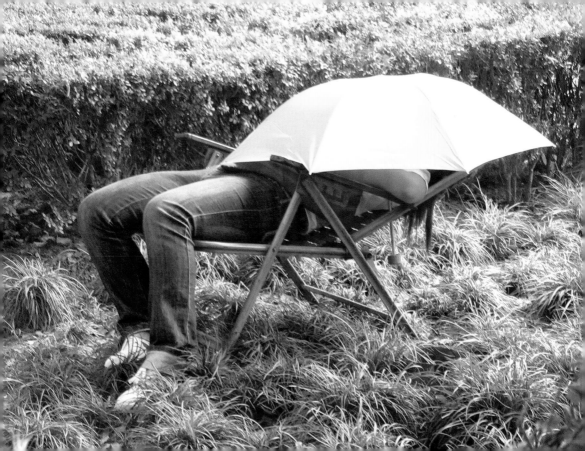

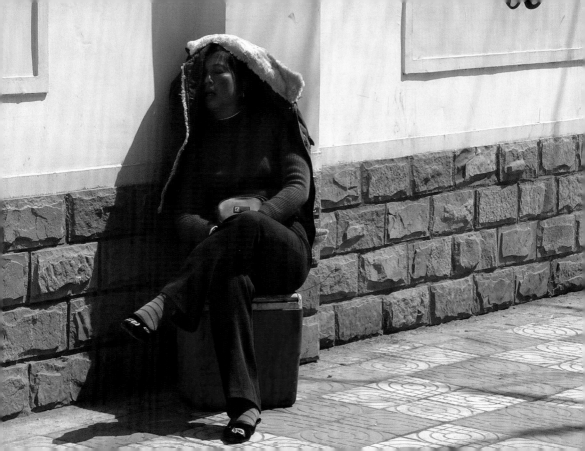

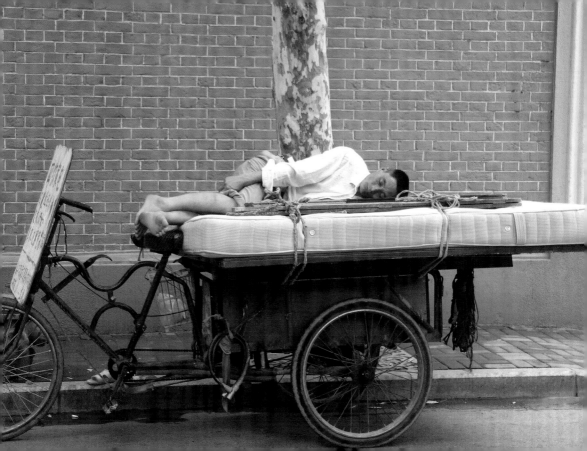

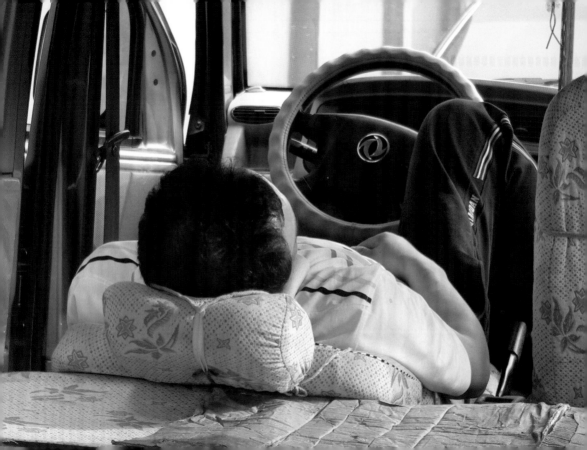

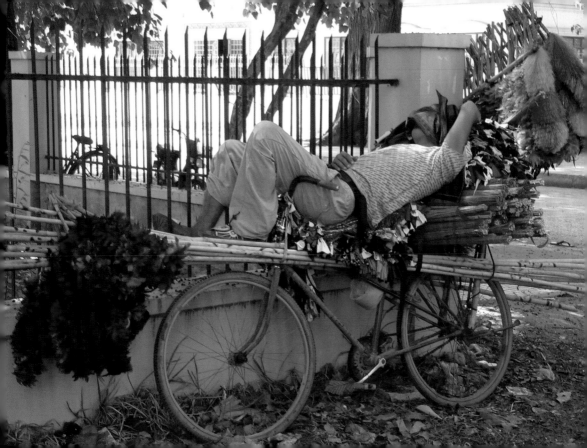

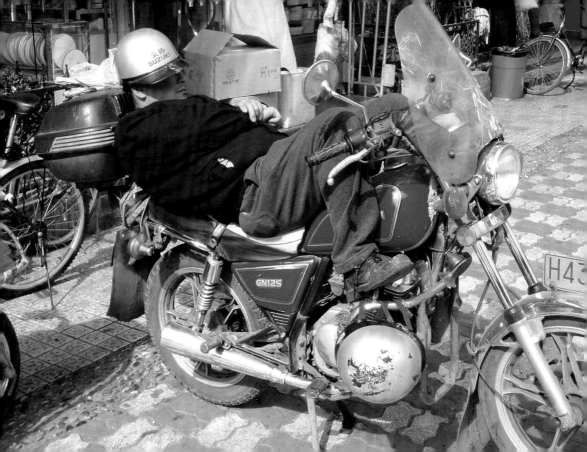

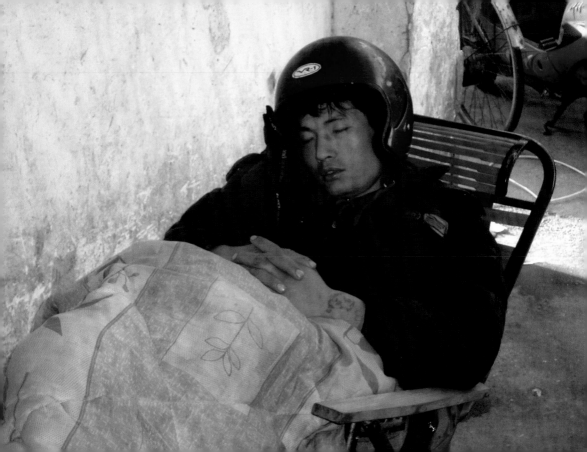

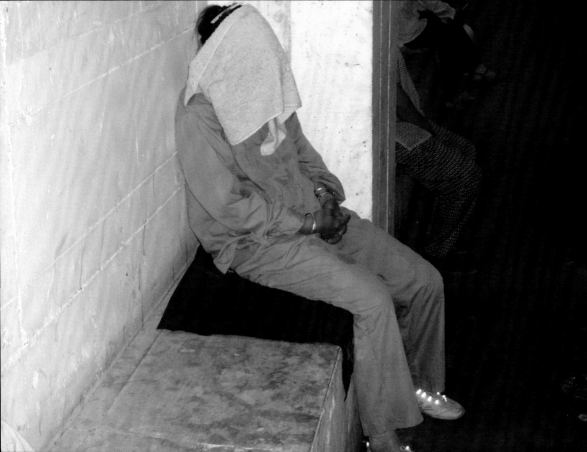

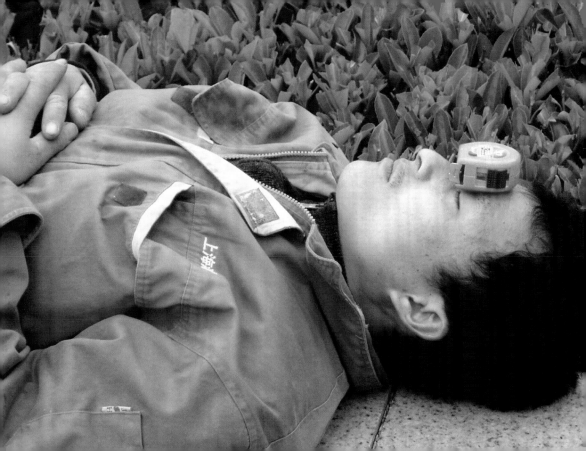

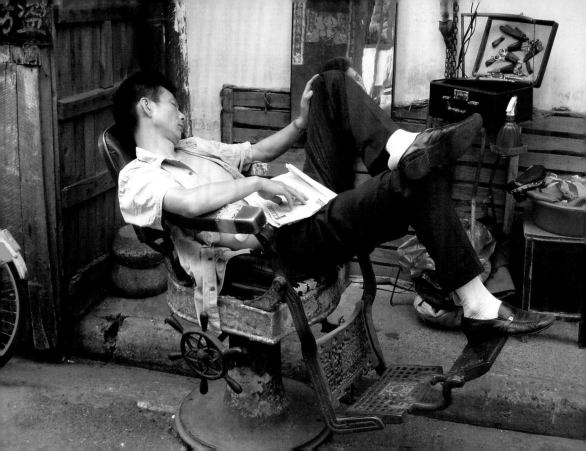

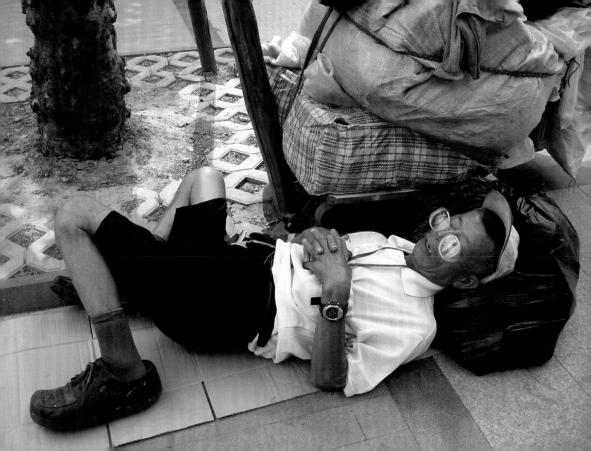

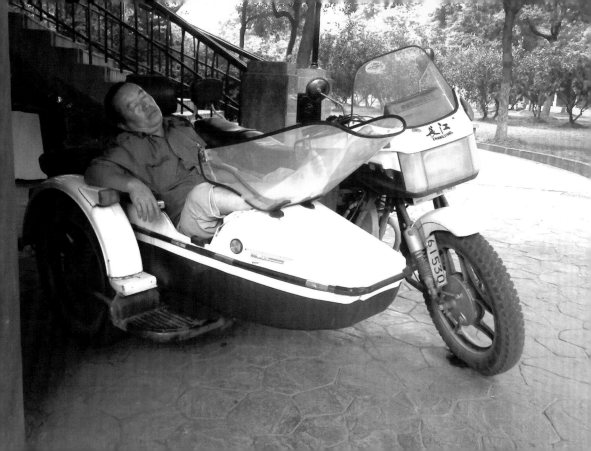

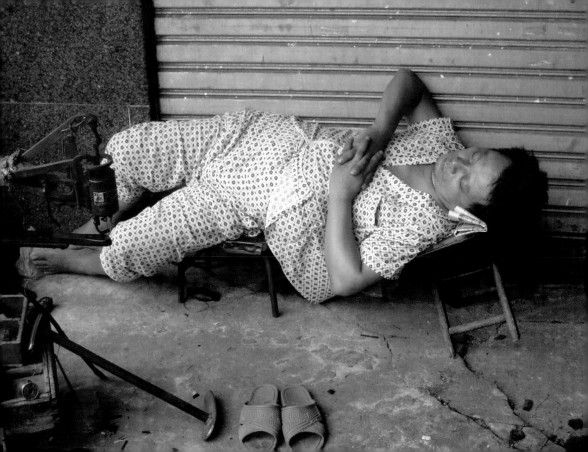

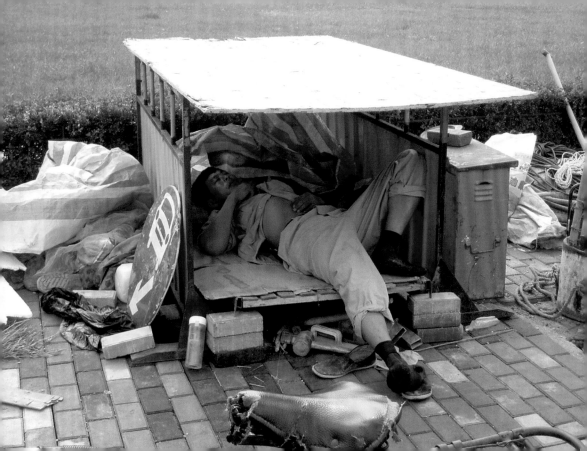

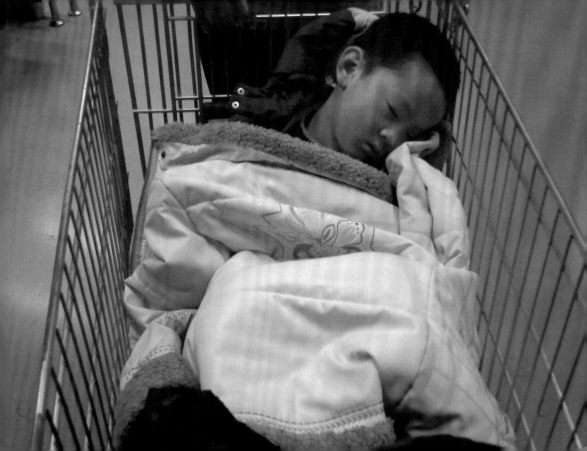

Group Sleepers

Yawning is contagious, but group sleeping can have its benefits. For example, two men on either end of a see-saw are almost perfectly balanced in height and weight, and their peaceful breathing creates a rock-a-bye motion to lull them to sleep. You're unlikely to be disturbed in an airplane compartment when everyone else's destination is the Land of Nod. And a traveling family need no pillows when they have each other's knees and shoulders.

群臥

打呵欠是具傳染性的,但是群臥也有其好處。例如在搖搖板兩端的兩名男子,身高和體重相約,相互在平衡著,他們平靜的呼吸聲像搖籃曲般哄著對方入睡。如果飛機上所有乘客都往睡夢之鄉去,你在機艙內很難有機會被吵醒。在另一個情況下,一家人外遊,並不需要任何枕頭,只要有對方的肩膀和膝蓋,就已經可以睡個好覺了。

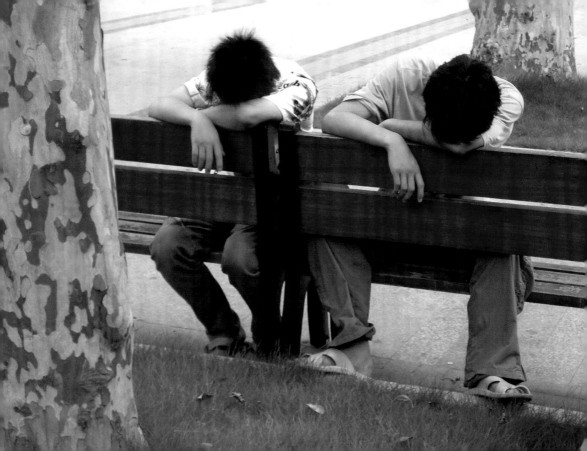

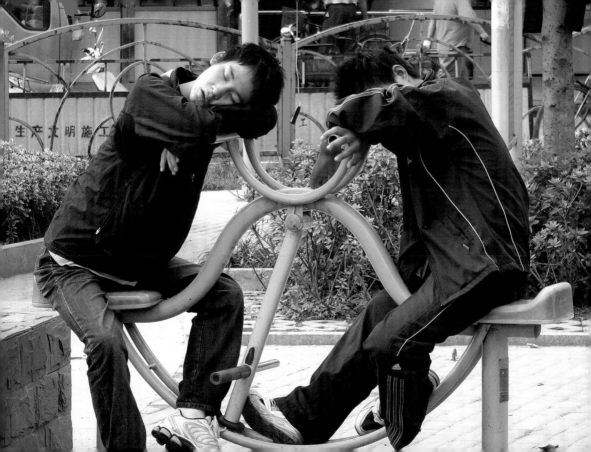

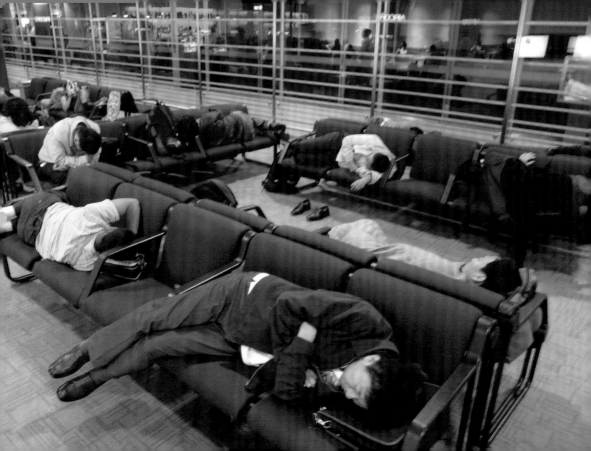

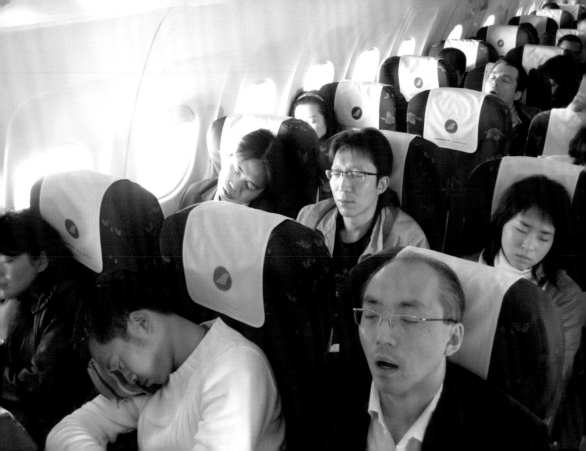

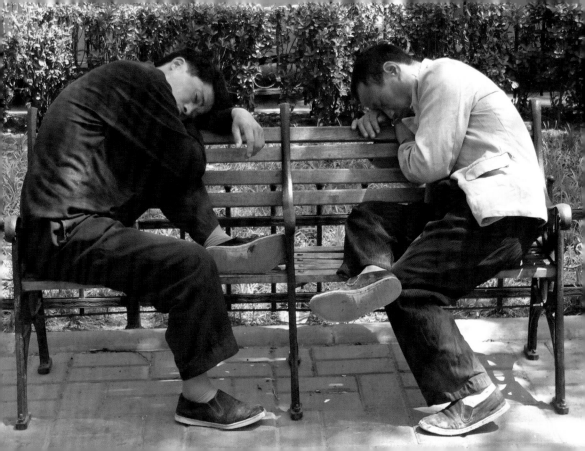

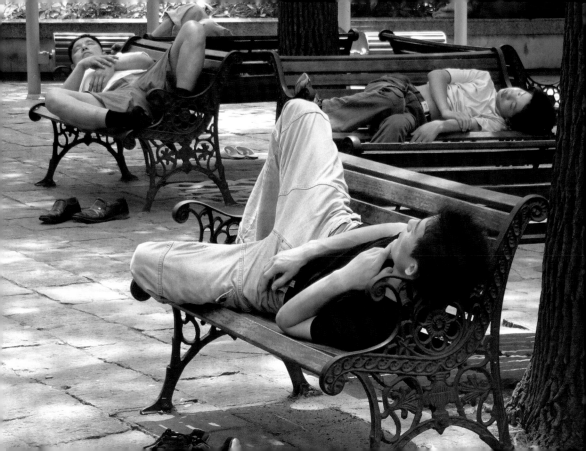

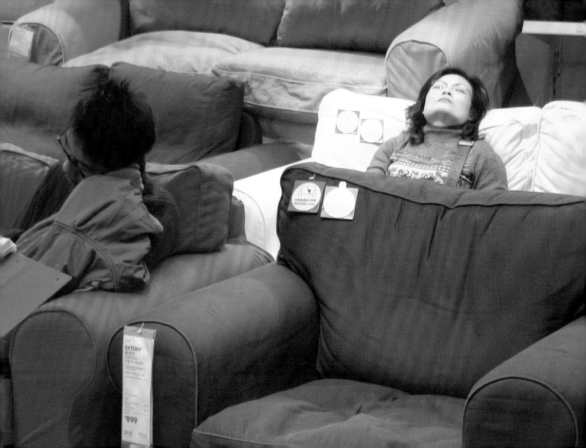

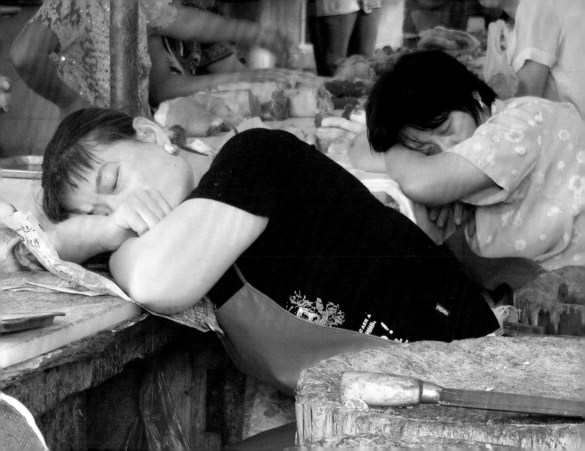

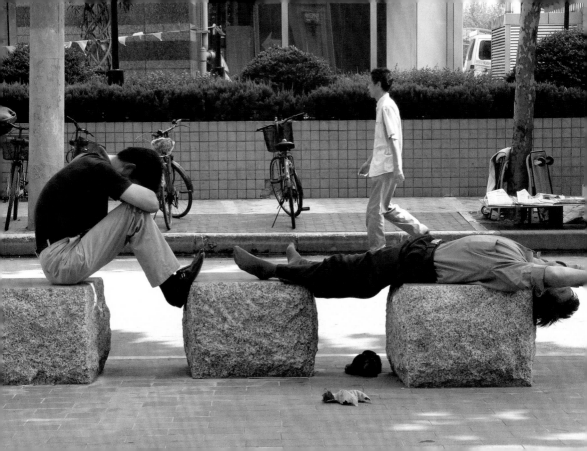

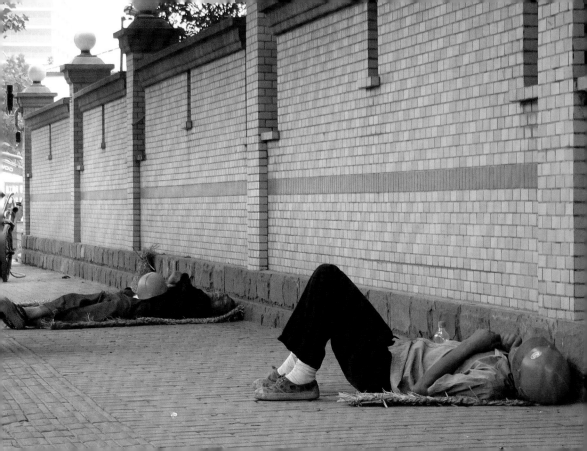

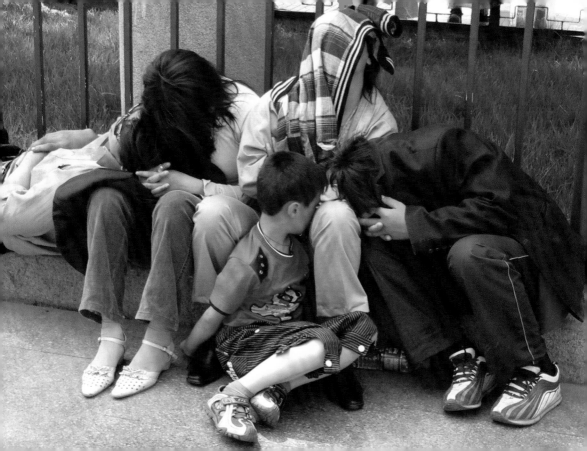

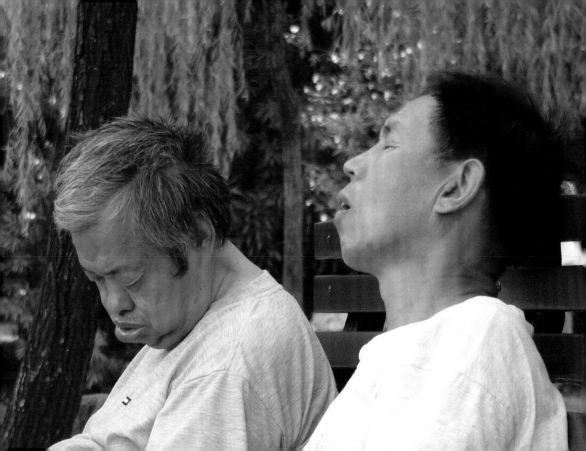

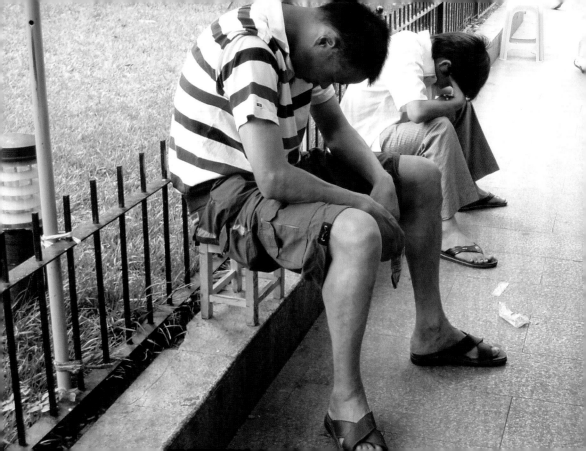

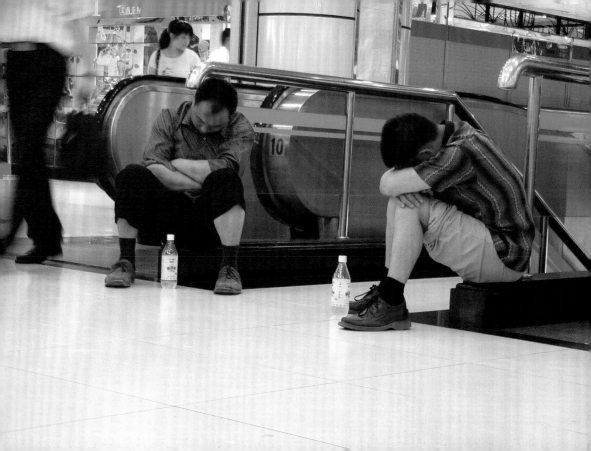

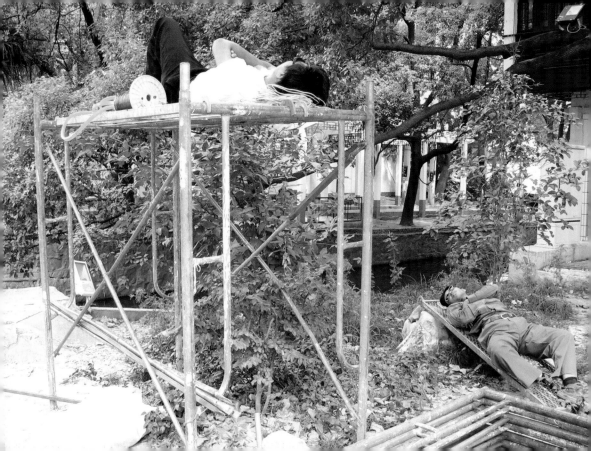

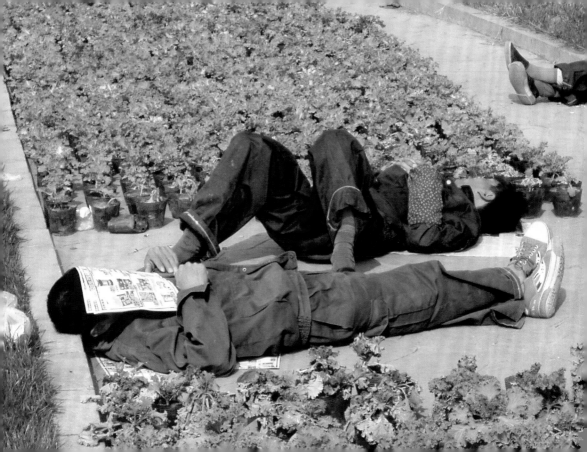

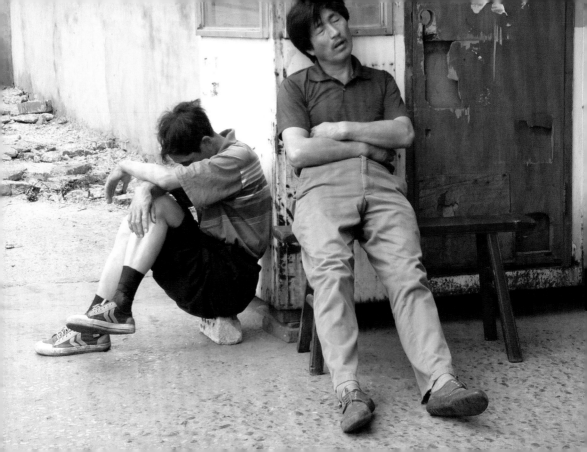

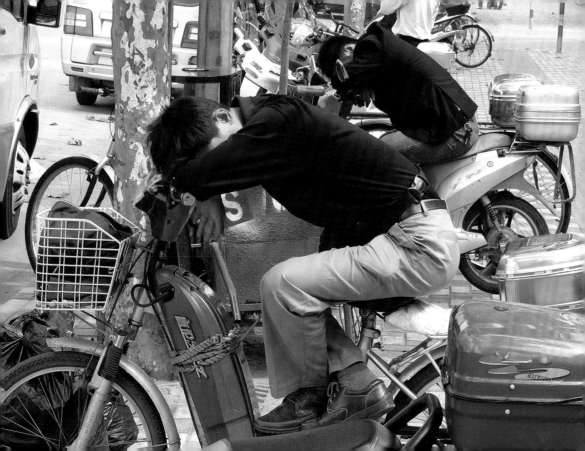

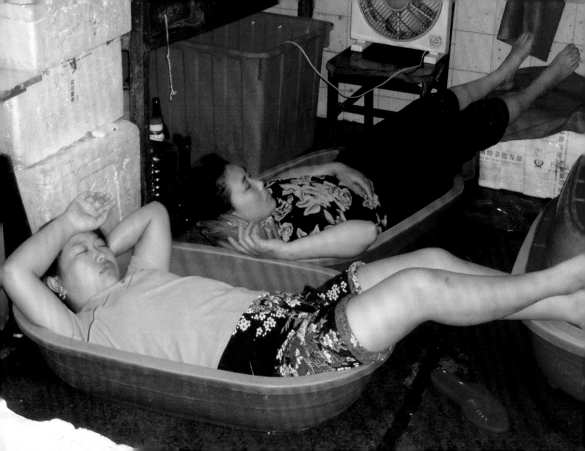

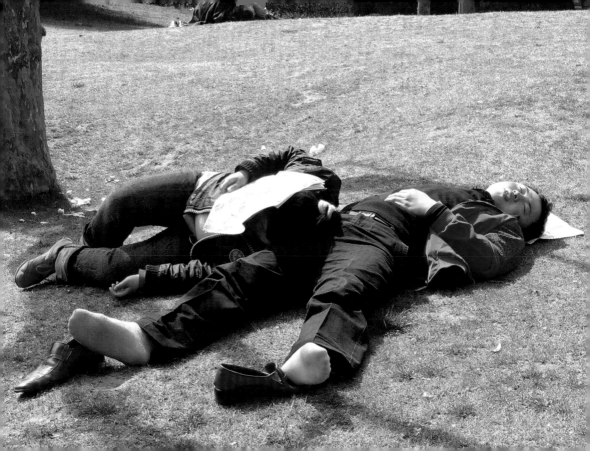

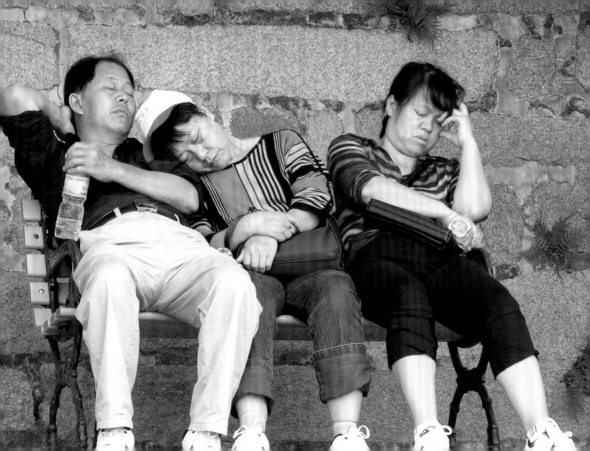

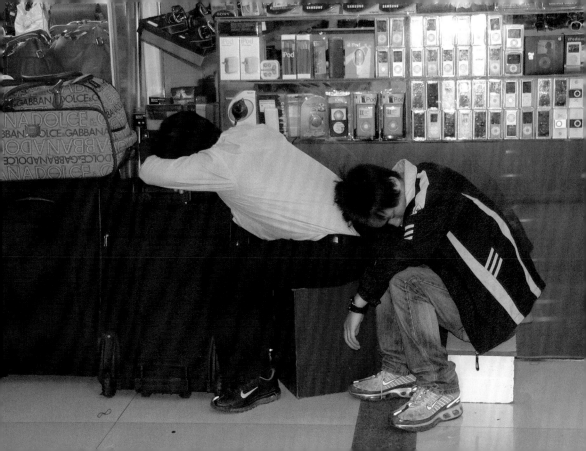

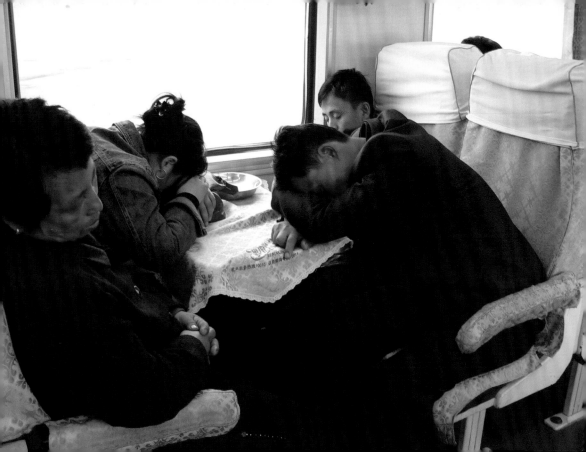

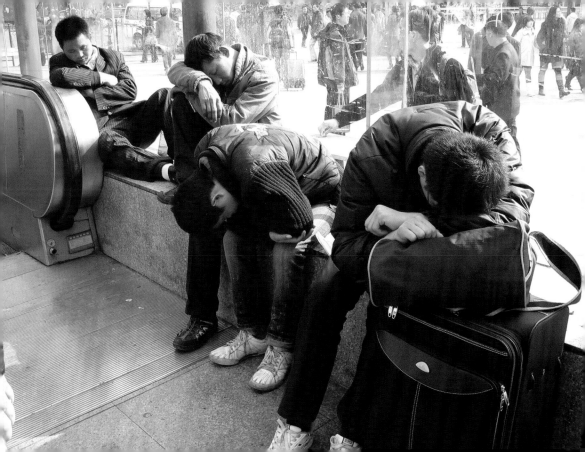

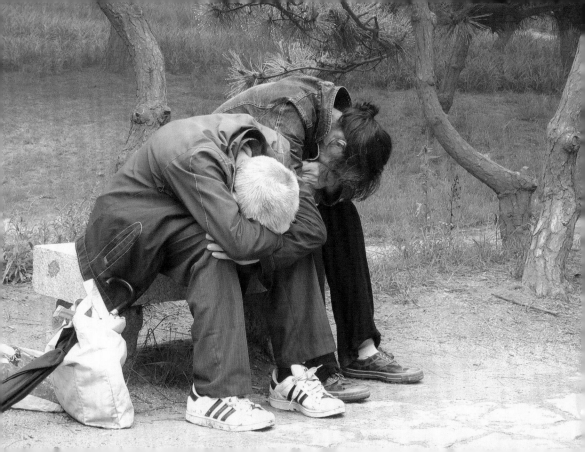

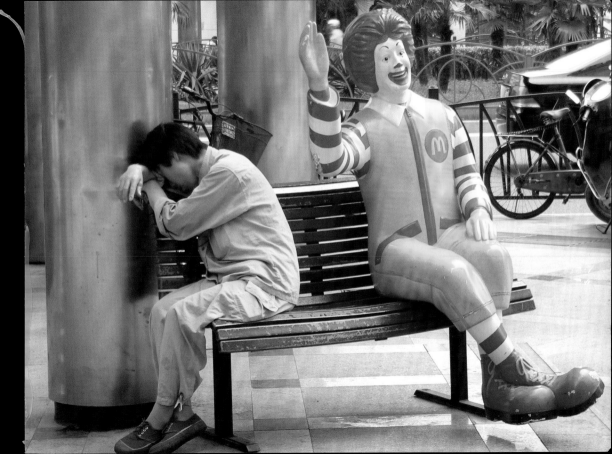

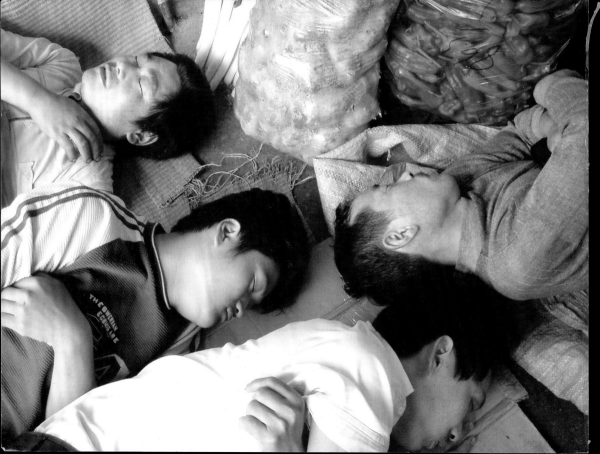